SCAPES

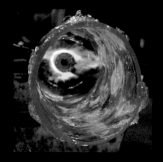

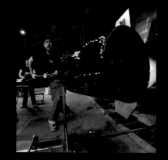
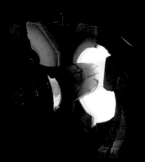

LEFT TO RIGHT, ALL FROM THE MUSEUM OF GLASS HOT SHOP: Making a cylinder; reducing a star; Gabe Feenan with a cylinder; reheating a mountain; shaping a star; firing a colored pattern before applying it to a star

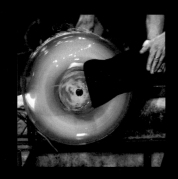

May the Being of splendor in whom the world dissolves and from whom it rises grant us a clear understanding. He is Agni, the lord-of-fire, and he is the Sun, and the Wind, and Moon. He is the Seed, the Immense-Being, He is the Lord-of-Progeny.

Svetasvatar Upanishad 4.1-4 [1]

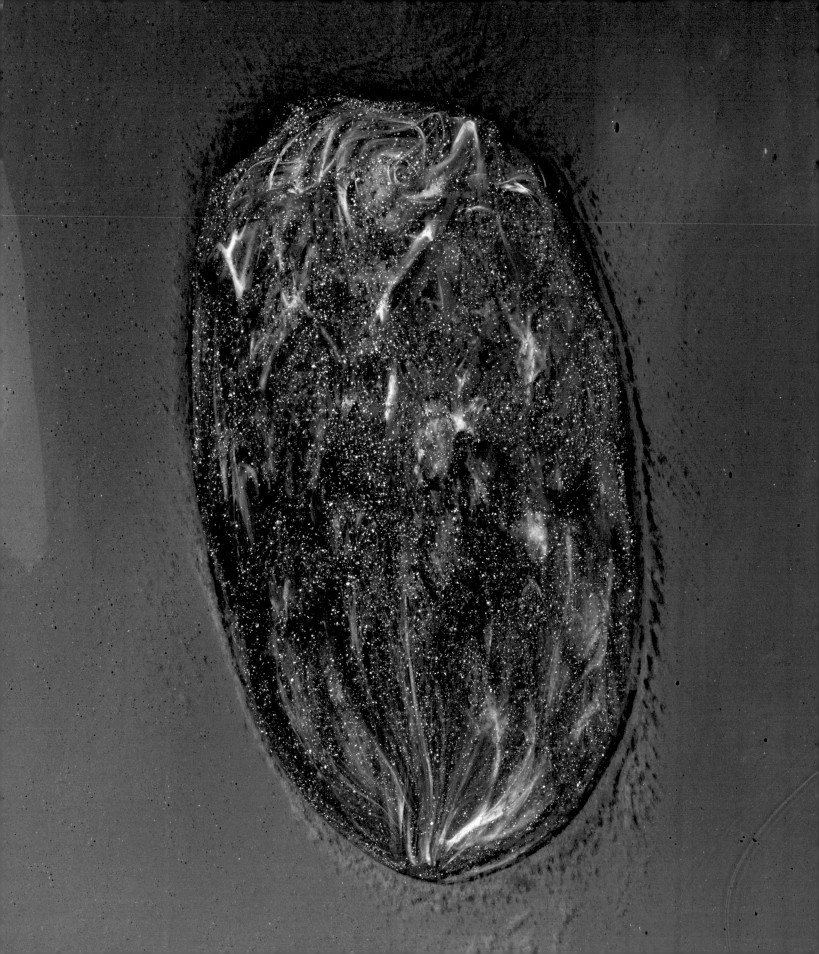

SCAPES

LAURA DE SANTILLANA

ALESSANDRO DIAZ DE SANTILLANA

MUSEUM OF GLASS, TACOMA

IN ASSOCIATION WITH

UNIVERSITY OF WASHINGTON PRESS

SEATTLE AND LONDON

Scapes is published in conjunction with the exhibition of the same name, organized by and presented at Museum of Glass, Tacoma, Washington, from April 2012 through March 2013 with an exhibition tour through 2014.

Library of Congress Control Number: 2011942962
ISBN 978-0-295-99188-7

SUSAN WARNER, project editor
LAURA IWASAKI, copy editor
MICHELLE DUNN MARSH, design
JOHN STEVENSON, production management

Color separations by iocolor, llp
Printed and bound in China

Published by
UNIVERSITY OF WASHINGTON PRESS
P. O. Box 50096
Seattle, WA 98145-5096
www.washington.edu/uwpress

MUSEUM OF GLASS
1801 Dock Street
Tacoma, WA 98402-3217
www.museumofglass.org

CONTENTS

FOREWORD

TIMOTHY CLOSE, DIRECTOR/CEO

MUSEUM OF GLASS

Scapes is a gloriously colorful, dynamic, and entirely new body of work imagined and executed by Laura de Santillana and Alessandro Diaz de Santillana. The siblings share an impressive pedigree in glass. They are the grandchildren of Paolo Venini (1895–1959), founder of Venini & Co. in Murano, Italy, and their father, Ludovico Diaz de Santillana (1931–1989), was director of Venini from 1959 to 1985 and designed for the firm. In addition to a venerable family history anchored in the traditions of glassmaking, Laura and Alessandro are respected artists in the international Studio Glass movement and have enjoyed successful solo careers. *Scapes* is all the more fascinating because it represents not only their first artistic collaboration but also their conjoined interpretation of intriguing aspects of Hindu cosmology.

The exhibition comprises four rooms, or installations, based on the Hindu belief that the world is a series of disks made up of wind, water, and golden earth upon which four continents float in a vast circular ocean. The de Santillanas have interpreted elements of this cosmology in glass, creating spaces in which forms and colors correspond to physical phenomena, or the visible universe, and evoke an atmosphere of cosmic vibration. Each installation is defined by a limited but strikingly vibrant color palette.

Alessandro Diaz de Santillana's work is distinctive—his 22 glass paintings were created from large, color-saturated cylinders slumped open into vibrant compositions that were then framed. Laura de Santillana's work is equally striking. Her elegantly sculpted forms, displayed singly and in small groupings, represent linga (complex symbols of Hinduism) or mountains, celestial eggs, and stars.

All of the work for *Scapes* was produced entirely in the Hot Shop at Museum of Glass, where the artists merged time-honored traditions of Italian glassmaking with the organic fluidity of the American Studio Glass movement. The practice of extending generous residencies through its Visiting Artist Program in order to create work for new exhibitions has become a hallmark of Museum of Glass. It has proved to be a popular and enriching experience for visitors and artists alike. The de Santillanas produced their work during two lengthened artistic residencies in February and September 2010.

On behalf of the entire Museum staff and Board of Trustees, I offer a heartfelt thanks to the de Santillanas, who have dedicated more than two years to realizing this exhibition and publication.

Many individuals deserve recognition for their dedication to this project and the contributions they have made to this catalogue. Essayists include Dr. Balkrishna Doshi, an architect of international standing and founder of the Vastu-Shilpa Foundation for Studies and Research in Environmental Design; David Landau, international businessman, collector, and art scholar; and Francesco Da Rin De Lorenzo, a renowned architect who has close ties to the Venini de Santillana family and a scholarly interest in glass as both an architectural and an artistic material. Susan Warner, Deputy Director, helped guide and shape this project over the long term, and the University of Washington Press worked closely with the Museum to produce this compelling publication.

The expert assistance of the Museum's Hot Shop has earned accolades for Ben Cobb, lead gaffer and Hot Shop manager, and team members Gabe Feenan, Alex Stisser, Nikola Dimitrijevic, Sarah Gilbert, Conor McClellan, and Steve Vest. Additional glass workers, Jay MacDonnel, Nick Davis, and Darin Denison also assisted with the project. Consultant Charlie Parriott also lent his considerable expertise in color and the technical nuances of making this challenging work. In addition, the following members of the Curatorial team deserve substantial recognition: Rebecca Engelhardt, registrar; Bill Bitter, exhibition designer; and Regan Samul, curatorial assistant.

We thank our stellar community of artists and specialists for their tireless support of the many facets of this project: gilding, Richard Boerth; metalwork, Paolo Croatto; mirroring, Byron Hensley, Hy-Lite Mirror & Glass, Inc.; photography, Russell Johnson and Jeff Curtis; transportation, Michelle Kinney, Art Work Fine Art Services; production work on eggs, Robert Krueger, Cascadia Art Conservation Center; photography, Chuck Lysen; catalog design, Michelle Dunn Marsh; production work on panels, Jay Norton, Ballard Refinishers; coldworking, Karsten Oaks; mold making, Josef Zuvac; and framing, Doug Tillotson, Museum Resource.

Special thanks to Erik Hammerstrom, assistant professor, Religion Department, Pacific Lutheran University, Tacoma and Amiee Butler, visiting assistant professor, Butler University, Indianapolis, Indiana. Thanks to Herb and Paula Simon who generously and consistently allow artists to reside in the cottage located on the grounds of their beautiful home.

The de Santillanas' amazing vision is realized through this publication, the accompanying DVD, and the exhibition. I know you will enjoy this intellectually complex and fascinating work with its exquisite attention to detail.

REVEALING THE SELF

DR. BALKRISHNA DOSHI

Life's hidden doors often open onto the most unexpected encounters. They simultaneously trigger flashbacks, dormant memories, and associations. As a result, these visions reveal to us the most unexpected insights. Such was the case when I met Laura de Santillana and Alessandro Diaz de Santillana, the famous Italian artists from Murano, Venice, at Sangath, my studio in Ahmedabad, India.

It made me recall my visits to Murano after the enchanting journey through the Piazza San Marco to the gorgeous basilica of San Marco and the Doge's Palace. I distinctly remember my journey through the quietly flowing waters of the canal, their translucent colors overlaid with fleeting light and shadows leading to the world's treasury of glass objects and artifacts. These objects, with their variety of hues, transparencies, forms, and colors, are in some ways reminiscent of the translucence of the waters of the canals traversed.

Nevertheless, it was the late evening return journey through those silent waters of the canals that made me realize how the contrasting experience of both—static architecture and the fluid, fragile and thin yet strong glass objects—had seeped into my pores and created and awakened a deep sensuousness within me. It made me wonder how such experiences can unfold unlimited creative impulses in human beings. How can people simultaneously feel and integrate and transform all the essential elements and distinguish these elements in their lives? I believe that those who live with extreme conditions learn, knowingly or unknowingly, to absorb, imbibe, and express this enigma that creates such art, architecture, and lifestyles.

This observation led us to narrate to one another our innermost yearning at this particular stage of life. We wondered in what way it is possible to capture these experiences and express them in our new works.

Perhaps this is more aptly expressed in the phrase "All begins and ends here." So goes life in the Indian city. Suddenly, in a busy hour, a wedding celebration brings traffic to a halt, and a few minutes later, traffic halts again. This time it is a funeral procession! All these events are happening irrespective of whether the streets are tiny or wide, remote or dense with activities.

For us Hindus, the soul and its journey is the manifestation of divine energy. All elements, earth, sky, water, air, and fire—the Panchamahabhutas—are its varied and diverse manifestations. If we are to understand the meaning of life, its purpose, we need to surrender to the divine, which gives us energy, growth, vitality, nourishment, and space to expand.

The discussions continued, and we realized that it is the content rather than the experiential, or the formally defined container, that creates the memories that anchor us. In the sacred city of Varanasi, one sees the basic five elements constantly used either to nourish or to dissolve—everything that life brings forth.

At the hospital or at home, a child is born. Then he grows, wandering, bathing in the Ganges, learning, going to the Kashi Vishwanath temple. His routine of propitiating the Gods encompasses all the manifestation of the Panchamahabhutas. Every day he lights a lamp (fire) and goes to the Ghats to bathe (water). He exercises, drawing breath (air), and watches the sky for rain during summer droughts (sky). He touches the ground (earth) and eventually dies and is cremated at the Ghats.

There are different ways in which to contemplate creation or to determine the existence of our world. Hindus believe in giving every individual the freedom to choose the image of his or her Gods, since no one can describe with absolute certainty how God looks or where exactly he dwells. To us, he is omnipresent and dwells in the minutest of cells and connects instantaneously. There is no beginning and no end. He can be either isolated or together. As a result, all elements are part of his existence and perform multiple tasks.

For example, mountains and valleys, deserts and oceans, night and day are the same, yet the nature of each half of the pairs appears to be the opposite of the other half's. Our inhalation cannot exist without exhalation.

Shivlinga, the symbol of Shiva, is a part of the Hindu trinity: Brahma (the creator), Vishnu (the preserver), and Shiva (the destroyer). They are self-born. They are neither masculine nor feminine. Shiva is also benevolent. The Shiva lingam—Shivlinga resting on the yoni (female symbol)—is worshipped as one. So is Vishnu, or the Sheshnag, the multiheaded cobra that is believed to support Mother Earth.

Perhaps the flowing waters, the presence of Shiva temples, and the eternally moving life pose contrasting questions: the temporality of matter and the constancy of the eternal elements, the Panchamahabhutas (water, earth, sky, air, and fire), whose presence one sees all over. Life. Death. Eternity.

It is here in Varanasi; one feels the presence of the intangible. These omnipresent five elements, depending on their relative proportions, make up distinct and unique forms of matter, constantly evolve and interact with one another, create a situation of dynamic flux.

Pursuing the conversation further, and hence their trip here, Laura and Alessandro talked about their new concerns and their desire to create the most unexpected artwork. Laura's and Alessandro's lives have been successfully spent with glass and its virtuous transformation. When their search for beyond began, success in all spheres lost its meaning, and pursuit of it came to a halt. If glass objects are basic elements, are there other ways to reverse the order? Why can't the medium be the message, a new object depicting its essential nature? They were here, perhaps, to rediscover themselves through engaging with the paradoxes of life witnessed within the noisy, boisterous Indian city and yet withdrawing within themselves for intense meditation. Between the two extremes of engagement and withdrawal, they could perhaps permit chance or life itself to intervene and allow glimpses of another of its facets.

The Indian lifestyle, belief systems, and rituals include paradoxical situations depicting the enigma of life, death, and reincarnation. For example, the Ganesh festival is based on the belief of creation, dissolution, and anticipation. It has a sense of continuity as well as of rebirth, revitalization, and the unexpected suitable to time and space.

Likewise, there are stories, myths, legends that indirectly suggest the way in which to conduct oneself during uncertainties. "Samudra Manthan" is a story I always remember. It is about a struggle for power—of good versus evil, of duty or ambition—between Gods and Demons.

In the story, to procure the ambrosia and become immortal, the Gods and Demons use all the universal elements created for specific life but employed here as tools—the ocean, the tortoise, the tallest mountains, the Sheshnag (the multiheaded cobra). After agreeing to churn the ocean together, both ordinary and precious jewels along with poison and ambrosia are bestowed upon them. After several unexpected battles, the Gods procure the ambrosia.

For me to "create" the unknown, the struggle continues. But finally, all boundaries have to be ignored for the good.

Air, water, fire, light, and earth are independent, and often incompatible, but at one given point, they come together to create what we humans will never know. Churning is to be carried out at opposite ends, objective and subjective, by two enemies striving together in search of the unknown.

Poison and elixir, the fluids and solids, all come out of the deep recesses of our inner selves. In the mythical story of Samudra Manthan, the churning of the ocean depicts the way we go through life. This story ends with the emergence of precious jewels that appear as galaxies, stars, and all the wealth that we appreciate—everything becomes valuable, precious.

Months passed since our conversation on creativity and our respective searches. A few weeks back, to my utter surprise, a parcel containing large photographs arrived from Laura and Alessandro. I couldn't believe my eyes when I saw the glass objects of unusual transparency, colors, texture, and fluidity they had created, totally different from the work I had seen before. Though the objects were static, I could feel their movement, as if they were breathing with a subtle but dynamic inner movement, wanting to explode and engulf the surroundings.

I remembered our conversation at Sangath, a year and half ago, and their earlier well-defined works. Laura's and Alessandro's concerns, I realized, were no longer physical. They were beyond material; they were spiritual. They were intangible as against their earlier works. The new works reflect the explosion of the artists' earlier well-defined forms, depicting multiple meanings through configurations, reflections, diverse overlaps of colors, textures, and size.

The defined lingam—symbol of Shiva—Agni, water, and fire appeared to shift their boundaries through varied multilayered forms, configurations, and sizes with their unique reflections, radiating and absorbing the world around. They simultaneously depict both the form and formlessness or the visible and the invisible. In them, the static appears dynamic, and every view expresses different connotations.

TO BE A WITNESS, NOT A DOER

To get back to our real self, the source that nourishes us has to churn the oceans of our being and bring out the magical nectar-amrita. Only after consuming it does the spirit get its true strength. This great churning is known as Samudra Manthan.

OUR REAL SELF AND OUR WORLDLY SELF (THE EGO AND THE I)

To touch our real self from the world is a Herculean task. It is our selfless desire that can lead us to salvation.

Once our self is balanced, our life, career, and values are without ego, and then the churning begins, our passion—conditionally, constantly—comes out, but after total contentment, our real nature of desireless creations comes out.

In order to achieve the natural, so far not seen in their recent work, both Laura and Alessandro must have gone beyond being doers to being witnesses. This is the birth of a child without being emotionally involved or anticipating that something akin to desire will happen. "Whatever has to happen, will happen"—only act with devotion and leave the outcome in the hands of the universe, says Lord Krishna in the Bhagwat Gita.

As a result, manifestations appear in unexpectedly richer forms, as if natural. In each object, there is a story, but it cannot be described. It appears as if it is a myth. When I see the present works of both Laura and Alessandro, I get this feeling.

This way of working can come about only through internal churning.

After twenty years of success in their careers, satisfied yet gnawed by the desire to create, they break their ways of controlled working to flow and discover what can only be described as soul throbbing. As always, one can blow, one can heat, one can mold, one can add colors, but it is with absolute faith, even recklessly, that one must take the plunge. It needs absolute faith—a sense of total surrender. Then psychic memories and intuitiveness come and fulfill what is deep within us, and this can happen only when one is drowned in the energy. After satisfaction and contentment, real creation occurs. There remains no fear, since success and failure do not exist. Skills take their own place. Body and mind surrender to the soul, and the act of creation occurs. After a while, birth is accepted for what it would be. There is openness, comparison, and celebration.

Both Laura's and Alessandro's works explode into another realm of "glass artifacts" and become three-dimensional sculptures and installations. The experience is profound and deep-rooted but may not touch us if we are merely fascinated by well-defined form or connotations. The search for deeper meaning of life through understanding has given their recent work an indefinable and immeasurable quality. For me, it is a Revelation.

In its presence, we sense the same power as in our ancient symbols, suitable for "global concerns for silence and peace."

As and when such works are shown, they need to be displayed in smaller sections, in isolation, so that the observer has a chance to reflect.

It is a liberation—a new way of looking at art as well as a new way of grasping the meaning of real life. In their work, I see a deep-rooted connection, the negation of "I," and surrender to allowing the essentials of life, materials, and its making to take control.

THE DE SANTILLANAS IN TACOMA

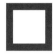

DAVID LANDAU

"We are always working on the future, not on the present," Alessandro memorably said to me in a recent conversation. And the future in the glassmaking process has one constant: uncertainty. One begins with a material that is unrecognizable in appearance, density, color, form, and weight from the work of art that one will admire and handle once it has cooled, the finishing touches have been made, and the right light shone on it.

Colors are not stable, as they change according to the temperature at any and every stage of the process. The de Santillanas have used German colors for this entire project, from a top-quality supplier who can guarantee reliability. Yet, a variation in the physical or chemical environment at the time the piece is being made or worked on can result in a surprise—good or bad. Colors have diverse physical properties and when they interact can influence each other in unpredictable ways: they may change, soften, harden, lighten, darken a neighboring color, altering the tone or chiaroscuro in the whole piece and rendering it brooding or lighthearted. One will find out only the day after, when the piece comes out of the *tempera*, the special oven for the slow and constant cooling process, necessary for the molecular structure of the glass to settle in the new form so that the item will not break when cold. The expectation is nerve-racking, and the very moment when this baby is slowly and carefully pulled out, and when light first hits it, is painful for the artist. It can be intensely satisfying, or it can turn into crashing disappointment or defeat. Every object is a one-shot opportunity. This is not Murano, not a production line where if an object is not right another can and will have to be made, then another, and yet another. A work of art is unique, and the de Santillanas are in the business of producing works of art.

During the arduous process of production many things can go wrong. The rim of a large piece may accidentally touch the edge of the oven when it is repeatedly inserted and pulled out, which happens dozens of times in the making of a single object. In the beautiful ballet of intertwined bodies, legs, arms, hands, fingers, voices, and silences of glassmakers at work one marvels at the rhythm, the grace, the strength, the delicacy of massive muscles and the subtle command of them that are necessary for continually turning an increasingly large, immensely hot, and fluid mass of glass. It is a long journey from the little incandescent blob of undifferentiated shape or character to—eventually and hopefully—a work that takes its place among its peers as a product of great ingenuity, novelty, stature, and universality, and which can inspire in us joy, sadness, elation, or doubt. But it is a journey that must sometimes take no more than minutes or, at most, hours.

If the piece does indeed touch the edge of the oven, the shape may forever be affected, may change in a way that is unexpectedly exciting or, on the other hand, frustratingly wrong and unacceptable. If the piece is large—and almost all the

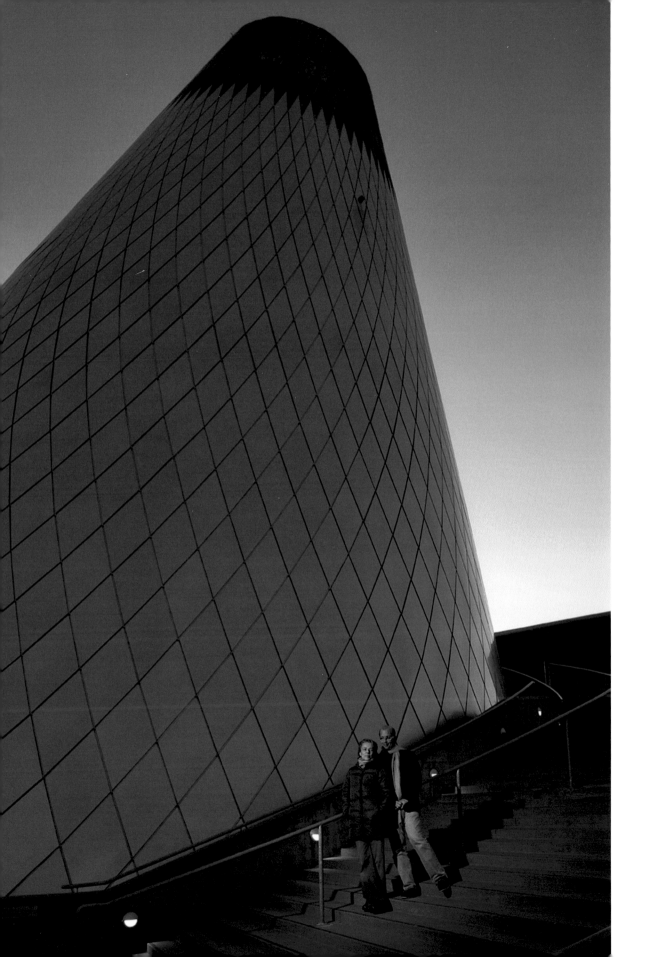

Laura de Santillana
and Alessandro
Diaz de Santillana
at the Museum of
Glass cone.

15

pieces made for this show are by all standards very large—the intrinsic weight of the molten glass and an insufficient, or insufficiently calibrated, or too slow or too rapid turning of it may produce a shape that was not intended by the artist. The gold or silver leaf may adhere excessively to the bronze table instead of taking refuge on the incandescent surface that is claiming it, or some of it may attach to the piece in an unexpected way. The powder may spread in a pattern it should not, or form an unexpected shape that would give the piece an entirely different meaning or interpretation from the original vision. How will the gold leaf break when the piece is blown? Will it spread evenly, maintaining its simple and severe quadrangular form, as in a fourteenth-century Umbrian gold-ground painting, or will it split into many parts? Will it develop winding irregular paths like the natural canals in the lagoon that surrounds Venice? How will the glass contract or relax at the two edges of a fold? Will it appear as heavy and constrictive, will it purse like disappointed lips, will it let go and relax like the lines of a wrinkled face that finds repose in sleep? How will the *murrina* interact with the glass it is resting on or pushed into? Will it stay proud of it, or will it collapse, caress, crease, or press on it in an ungainly manner?

To work on glass is, as a friend once said to me, pure acrobatics. If all goes well, it can be marvelous, but if it doesn't, it can be a disaster. The de Santillanas were brought up in an environment where very little was left to chance, where sketches were developed into designs and designs into large-format drawings, pinned to the wall next to the "operating theater" of the glassblower, and where the instruction was clear and the skill of execution measured in its perfect adherence to the model. In the day-to-day life of a glass factory like Venini, nothing was left to chance. Accidents must simply not happen, diversity was not welcome, departure from the prototype not tolerated. But at the coalface, in front of the burning Tacoma ovens, experimentation is a way of life. Glassblowers brim with confidence and excitement, constantly challenging themselves to do more, to invent something new, to try a solution that is novel and surprising, that will give the piece in hand a unique character that they can recognize as their own.

I know from interviewing them repeatedly that both Laura and Alessandro felt somewhat threatened by this constant pushing of the fine line between designer and maker. They found it equally gripping and stimulating but wished at times they could be more in control of what was happening. The sheer speed of the process was probably one reason this was not possible: in truth, this whole exhibition was put together in four weeks of intense work over two visits, in February and September 2010. To be sure, it was carefully planned in advance; detailed drawings were produced and there was all the mental and practical preparation that one would expect from experienced artists of glass. But in the end, the two Venetians found themselves confronted by well-organized teams of knowledgeable, experienced, creative glassblowers who kept pushing the boundaries further and further. Three ovens were blazing at the same time, a large and vociferous public was participating as in a Roman arena, and decisions had to be taken instantly and adventurously. Would the results meet the artists' original expectations? Would they even surpass them?

Laura is a thin, delicate, almost fragile woman, even though a steel rod—probably covered with gold leaf—is hidden within her body. She is pensive and thoughtful. She creates slowly, develops ideas organically, and needs time to absorb, consider, and debate within herself the effect of her ideas on the objects she will give birth to. And the Venini story is deep inside her, the long experimentations with pencil and paper at a table before even starting to think whether a piece will actually see the light of day, seeing perhaps her grandfather Paolo and certainly her father, Ludovico, bent over their desks in the office or at home in the evening, thinking through new shapes, new forms. It is hard to imagine her in the midst of the organized chaos of the three Tacoma ovens, trying to stay on top of the activity, attempting to control a process that at every moment seems to be led in new directions by the creative will of wonderfully expert glassblowers. No

doubt the results will be interesting, and probably even beautiful, but they will also need to be expressions of the soul of Laura de Santillana.

The constant thought of coping, even battling with that all-American feeling that there is no limit to experimentation, that however treacherous the land ahead of you beyond the horizon there will be a pasture of milk and honey, was immensely stimulating for the artist, even though at times undoubtedly terrifying. Chance is a difficult and often unwelcome companion for the professional artist, whatever the outward appearances: Pollock's drips may appear to most as mere chance, but to him they were as deliberate as Raphael's delicate brushstrokes. But time is money, and Venetian reticence finds no easy place in the ebullience of Seattle glassmaking. With the immensely satisfying power of hindsight, we can now safely say that it all ended well, that the pieces made for this exhibition display in equal measure the studied approach of their creators and the vitality of the glassblowers who helped to realize their dreams.

Perhaps because I admire—nay, envy—artists for their ability to create beauty out of so very little, perhaps because I have sat for the painter Frank Auerbach as a model every week for the past 27 years and have seen art, great art, being made in front of my eyes out of nothing more than a still model and some oil paint, I can empathize with artists. I feel intensely the anxiety that comes with creation, the humbling uncertainty about one's own worth as a maker faced with the challenge always to improve on one's previous work, let alone that of countless others who have labored with the same alacrity and dedication for centuries before. It is difficult to say something new and meaningful in painting today, but at least canvases don't split in front of one's eyes the day after they have been laboriously finished, and sculptures don't suddenly disintegrate while standing on a window sill. Glass pieces do. It must be terrifying to work in the knowledge that an exquisite, challenging, large piece that you have just completed and that looked splendidly promising and made you proud on the day of its creation could just crack as suddenly as lightning can pierce a cloudless sky.

During the preparation for this exhibition, Laura and Alessandro lost a dizzying percentage of their finished pieces in this way. I am not talking about those molten masses that suddenly fall on the floor in a moment of distraction while the glassblower is taking them out of the oven, or those that already appeared so compromised in shape or scale when hot that the decision was taken not to spare them the death of instant cooling. I am talking about the great successes, the hard-won triumphs after a day of disappointments and anxiety, the exciting pieces put with loving care into the *tempera* in the promise that they would reveal themselves in all their beauty the next day. The more ambitious and experimental the piece, the greater the mixture of different varieties of glass and color used, the greater the daring combination of powders or glass fragments, the higher the risk of breakage when it is cold.

Anxiety is a way of life in this business. Traveling the 5,465 air miles between Venice and Tacoma on two occasions is enough to cause unease. To have to do so immediately after a dramatic and exciting week at the ovens, not knowing what will survive, is punishing. To be told, day after day, that yet another of the babies one has left behind is no longer must make one feel truly small. Will the pieces that looked so good when the artist last saw them look equally convincing on the next trip? Will they stand the test of time, or will something that seemed a trivial defect the first time round reveal itself as a fatal aesthetic flaw? Photos, of which Laura and Alessandro had plenty to return to Venice with, can be very deceptive and may increase a sense of quiet satisfaction that is then shattered by reality. Add to that the uncertainty of not knowing whether, the next time you will be standing in your jet-lagged state in that hot arena, you will succeed in emulating or, hopefully, surpassing the quality of what you had achieved on a previous occasion. Will a series of glass pieces put together so spasmodically, in a few short days, look sufficiently coherent, and will it speak as a unified and

meaningful oeuvre? Who will be the glassblowers next time? Will they be as friendly and competent as last time, and will they really understand what the artist has in mind and is trying to achieve? Or will they try to prevaricate and create something that might be more their own work than the artist's?

Both Laura and Alessandro are superb professionals, totally purist in their approach. The final object not only has to work at an aesthetic level but has to be perfect in every aspect. It has to be finished meticulously, must be clean of impurities, scratches, and anything else that could affect its perception. Alessandro, for instance, covers the sides of his slabs with silver, gold, or copper, which has to be applied as if it had been made in the oven, and as if the cylinder that it once was had never been torn open. One is immediately reminded of their grandmother Ginette, arriving in Murano on her elegant motorboat every morning from her house in central Venice, settling down at the large table where all the previous day's production was laid out for inspection after cooling. She would check every piece individually, and those found to be imperfect, sometimes in a minute detail, would be destroyed or, in a few rare cases, given to the master blower who had made it to take home. But not before he had been summoned by the owner's wife and the problem discussed with him fully, so that a technical way could be found to avoid it in future. This discipline informs everything in the de Santillanas' approach and is revealed above all in the principles behind the creation of these iconic Tacoma rooms.

There are four of them: Earth, Space, Sun, and Moon and Constellations. The meaning of this choice and its relationship with Hindu cosmology are explained elsewhere in this catalog, but the choices made by the two artists in selecting shapes, color, textures, and finishes and in defining the internal relationships among their creations are so clear and well defined that they speak for themselves: a child would know which of the rooms he or she is in. The three guiding principles for each room are color, vibration, and atmosphere: these are very effectively translated in the discourse between the wall and the floor pieces, the glass paintings by Alessandro and the glass sculptures by Laura.

Alessandro started photographing at the age of 13 and painting at 14, and although he has been a glassmaker ever since, both as a designer of objects for commercial production and a creator of works of art in glass, he has often reverted to two dimensions. His mirror-glass pieces, in which space and our perception of it are continuously fragmented by planes at different angles and by textures that alternate between shiny and reflecting on the one hand, and matte and light-absorbing on the other, have consistently ventured along the tenuous boundary between painting and sculpture. It seems to me that the process of proclaiming himself a painter with glass is coming into a climactic phase in this show. Even if Alessandro is here doing away with frames, which may suggest that he is now moving instead toward sculpture, the reality is that the impact of his present work is based on two dimensions, however rich one of them may be through the manipulation of surfaces.

On the other hand, there is little doubt that Laura is a sculptor, with a long history of employing a language that expresses itself through form in space. One does not just look at her work, one walks around it, physically and mentally, touching and caressing it (unfortunately not possible in a public exhibition). There is a tactile materiality in what Laura makes, a sensual attention to curving surfaces and wonderfully soft and tender textures, and an almost painful perfection in color combination and the use of transparency and translucence as a means of relating us to the space beyond. Her pieces, however chunky and heavy they may be, are always an attempt to give light itself a shape, a form: she turns weight into a way of interpreting what is behind it, the air that envelops it and the light that gives it substance.

It was the intention of the two artists—at the moment of writing it is too early to know whether this will be fulfilled in the exhibition—that the rooms will be defined not only by the pieces in them but also by the color of their walls and floors

and by the "gates" that connect them. These are meant to be meaningful transitions from one sphere to the next, such as a wall of cold light in silver that introduces us to the Space room, or a pitch-black passage leading us into Moon and Constellations. Once inside, the eye will be drawn to Alessandro's wall pieces and Laura's floor ones, which were made to talk to and complement each other, so as to enhance the feeling of earthiness, the omnipresent sun, or whatever else. It must have been a curious process—one to which we are not privy and whose mysteries we do not presume to discover—for a brother and sister to work so closely on a project in order to create what is ultimately another work of art in itself, this exhibition. There is of course plenty of precedent, from the Carraccis to the Chapmans, but it is the individuality of these pieces and their distinctive and irreplaceable contributions to the whole that make this collaboration so special.

The Tiepolos, just to name a dynasty, came from a long line of relatives who worked together on important commissions, and Fischli and Weiss are but one example of the current trend of duos, trios, or even large groups of artists who get together to express themselves in a single voice. But few, if any, in the past have symbiotically produced uniquely individual and yet separate pieces that are then drawn together to create a greater work of art. For those lucky enough to know Laura and Alessandro well, there can be little doubt that they communicate as monozygotic twins, even though they were born years apart: they can share artistic thoughts and ideas with a glance or a body movement. It is always disconcerting to see them together, as they seem to exist on a different plane, perhaps in one of the spheres that they have reimagined for us in this exhibition.

Alessandro made six pieces for the Earth room, Laura six. His paintings are achieved by blowing a cylinder of glass in a mold, which is then cooled, cut with a saw, and reheated slowly until it opens up naturally and lies flat on the surface of the oven, in a process similar to the time-honored method of making rolled glass for window panes. But there is no transparency here: these six pieces evoke the patterns carved by water, heat, and wind into the surfaces of ancient, now dried lakes and the corrugated walls of worn mountains.

Nothing is left to chance in the glassmaking process, even though it is the result of much exciting experimentation, frustrating failures, and stubborn remakes. For instance, the beautiful white waves we now see on *White Earth* come from a complex procedure that involves adding from the top of the transparent crystal cylinder (at this point only one third of its final size) a layer of *lattimo*, or white opaque glass, pressing it into a patterned (*rigadin*, it is called in Murano) mold that opens a myriad cracks in it, filling these cracks with appropriate powder, and plunging the whole in water for a brief moment, so that only the surface of the cylinder breaks into a melting-ice pattern. Then comes the blowing of the piece to full size and the whole process of cutting the cylinder open, reheating it and, once cold and slumped, that is, flat, covering it with liquid silver nitrate, which produces a very fine silver layer that will need fixing with a varnish. At last, the piece is finished by removing any accidental impurities and damage and treating its exposed, rough edges so that they complement the integrity of the piece rather than distract from it.

For this room, Laura has chosen the mountain, as an archetypal symbol of Indian cosmology, omnipresent in that country in endless and multifarious ways, and made in any material, from metal to powder. Her mountains are not descriptive, but one cannot but be reminded of the columnar rock formations in distant lands, from the western regions of China to the stepped peaks and plateaus of New Mexico. But their surfaces here suggest calm rather than ruggedness, and generality rather than specificity. There is a rather disturbing relationship between these mountains on the floor and the images on the walls that evokes the primitive state of natural spaces, with untouched birch woods, relentless waterfalls, and smooth rock faces unchallenged by man.

In the Space room, the works of the two artists are not meant to be seen as tied to each other, even if obviously complementary and intended to create a common effect, but they have a life of their own. Most of Laura's eggs are white or translucent; all of Alessandro's glass pictures are silver and mirrorlike. Neither group, however, is pure form. The surface of the glass images is strewn with bubbles: thousands of them, in lines, drops, groups, and islands, and in wounds. They are mostly in the center of each piece or spreading out from it—a technical feat in itself, as they were applied when what we now see as a flat glass painting was still a transparent cylinder—and were produced by using calcium bicarbonate, either in its original form or slightly diluted in water and spread on the glass by means of a thin stick or a kind of water pistol. When, as in *HG S1*, Alessandro wished to stop the bubbles from taking over the center of his piece, he used a round metal plate lying on the bronze table before the bicarbonate was carefully spread around it.

Laura's eggs follow a trajectory that starts from simple, pure form and ends with the complex structure of the human brain. Their surface is initially crystal clear, or a combination of transparent and opaque glass, yet one soon discovers that something is happening. As in nature, the egg starts to divide itself, time and again, and inside it the earliest form of life begins to take shape. It is an increasingly large bundle of a long tube, an intestine-like knot of a glass pipe, becoming ever more dense and opaque. Meantime, the surface of the eggs gets richer in texture and color, the fragments of mica powder appear and silver leaf is added, clouding the vision of the miracle within. When one manages to make sense of it, it has mutated into a brain, a white, equally pristine brain, which itself slowly metamorphoses into one that is touched by silver and gold, both of which help to delineate the recesses between its lobes and wrinkles. Intelligence is born, in the light of pure space.

For an obsessive collector of Venini glass, as I am, it is very tempting to look at all this through the lens of history. The bundles within the eggs instantly throw us back to Martinuzzi's vases made for the family firm in 1930, with large bubbles, flowers, and fish seemingly floating within a transparent bowl of water (left, above), while the separating eggs closely echo Carlo Scarpa's gourdlike shapes of about 10 years later (left). What to say about the textures and surfaces of many of the pieces in this show? When looked at closely, they remind one immediately of their natural, though perhaps distant, antecedents: the *pulegoso* glass of Martinuzzi, the *bollicine* of Scarpa, the wonderful surface effects devised by Buzzi with *lattimo*, silver, and gold leaf in 1932–34. Laura and Alessandro are imbued with this history; it is in their bones, and their blood runs through arteries and veins of Venini glass. However much they wish to hide it, and both physically do so whether under a platform or in a wall cupboard in their studios, they are rightly proud of it. Venini, which they came both to love and to think of as their future, was aggressively robbed from them, and the wound is somehow still open. Only in making great glass that pays a tacit but respectful homage to the Venini tradition will they be able to exorcise this demon.

Alessandro's six paintings in the Sun room are born very specifically from photographs of the sun (page 21) taken from a space telescope. The glass works very clearly emulate these exceptional images, both in their formal structure and in the choice and richness of color and texture. There is the constant presence of an egg-shaped form in the center, which grows larger and larger as the series progresses and turns from an air balloon into a jellyfish, as Laura has suggested, and back. It is created from a large *murrina*, a dollop of structured glass prepared beforehand, and protrudes through the skin of the sky as if it wished to be birthed out of it, disturbing the surface by creating folds and stretch marks. Laura's two linga and nine cosmic eggs are a direct response to Alessandro's disturbed, though still flat

Na-

poleone Martinuzzi for Venini & Co., vase, 1930

Carlo Scarpa for Venini & Co., vase, 1942

ovals. They are big, sculptural, and proud, like sudden eruptions from the molten surface of the sun before they transmute into coral-like bursts of red tongues. The eggs start rather small and dark and grow in scale, lighten in color, and increase in complexity and ambition as the series develops. Mica powder roughens the surface of some, spots enliven others, a huge gold leaf dominates one while iridescence enriches another. An exquisite white calligraphy of marks characterizing one of them is the result of patient intervention with a delicate hooklike tool applying *lattimo* to the preexisting layer of clear glass: these myriad effects are the product, yet again, of endless trial and error in a search to give flesh to Laura's clearly articulated but difficult-to-achieve dreams.

Space telescopes played an important part in the Moon and Constellations room; a set of photographs inspired Alessandro to begin his voyage through the skies. As if to reconstruct the infinite variety of colors in distant galaxies, he put together many fragments of strongly colored glass on his bronze table, creating patterns and designs that reminded him of the telescope images, heated them, and eventually collected them with precision on his hot cylinders, so as to re-create on the walls of this room, which is envisaged as dark and mysterious—like the deepest of desert nights, the only time and place where these marvels of nature can be imagined—the effects that only telescopes can produce while hovering in the space we contemplate. Laura responded with real stars, with shapes that remind her of the lotus flower and the rotating disk, both attributes of the god Vishnu. These are large disks, flattened at the bottom, with their surface marked by the effects of applied leafs or powders, or both, by combining such powders or delicately brushing them. At the center of the circular form of the sky, the square—symbol of the Earth—surrounds and protects the brightly colored dot, the *bindu*, from which the whole universe will expand. Some stars are much simpler in appearance (though emphatically not in their making), with their white, strongly iridescent folds hiding, as Laura explained to me, their beauty in the mystery of what is perceived to be there but is never seen, an effect that she likes and that informs much of her work.

Strength and grace characterize the most striking of the last three white stars, where a complex structure of red powder, embraced by gold leaf, with silver leaf at its margins and an intense and surprising red, opaque, but vivid *bindu* at its center, plays together in a kind of constrained beauty against the intruding and ungainly presence of a big *murrina* that pushes from below and changes the color of the glass it is embedded in. Nothing is simple in Laura's work, except its appearance.

I have insisted on calling these works paintings and sculptures, because this is what they are to me. To be sure, they are related, intimately, with Murano's glass and with the techniques developed there over a thousand years, not to mention with the daily experiences of the young Laura and Alessandro at the Venini factory, where they still describe that "smell of glass" they sensed immediately on entering the building. But they stand, with their own distinct and individual voices, in the panorama of twentieth-century art. The de Santillanas spent their youth in a family where art was hanging on the walls and was a way of life, in the world's most beautiful city, where the Biennale every two years would reveal new and exciting developments and from which regular family trips to foreign lands were punctuated by museum visits under the guidance of their learned and enthusiastic father. Walking through the four rooms of this show, let alone through these two artists' entire oeuvre, how could one possibly doubt that they saw Dubuffet, Tàpies, Pollock, to say nothing of Fontana, Buzzi, and Fautrier? That they felt affinity with the Art Informel shown in Venice during their formative years? And why would they not today be comparable and compared to Kiefer and Barceló? Can prejudice last forever?

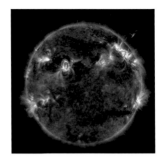

NASA/Solar Dynamics Observatory/ Atmospheric Imaging Assembly, Color Enhanced Telescope Image of Sun (*Popping all Over*), March 6-8, 2011

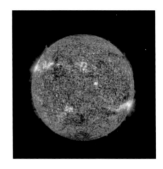

Solar and Heliospheric Observatory (European Space Agency and NASA), Color Enhanced Telescope Image of Sun (*Popping Off*), October 25-26, 2010

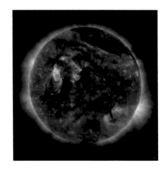

NASA/Solar Dynamics Observatory/Atmospheric Imaging Assembly, Color Enhanced Telescope Image of Sun (*Great Ball of Fire*), August 1, 2010

SPACE

(**Shuya**) At the root of everything that is is space. Ultimate reality, or Brahman, is without any characteristics, and is clothed first in empty space. However, space is not mere nothingness; it is creative. It is a profound silence that produces the original vibrations of the universe, its original song; it is envisioned as a primordial egg, or golden womb, that divides into Heavens and Earth and actively gives birth to all the other elements (earth, water, fire, and air). After this creative work is done, space continues to surround us, and the full weight of our world rests firmly upon its vastness.

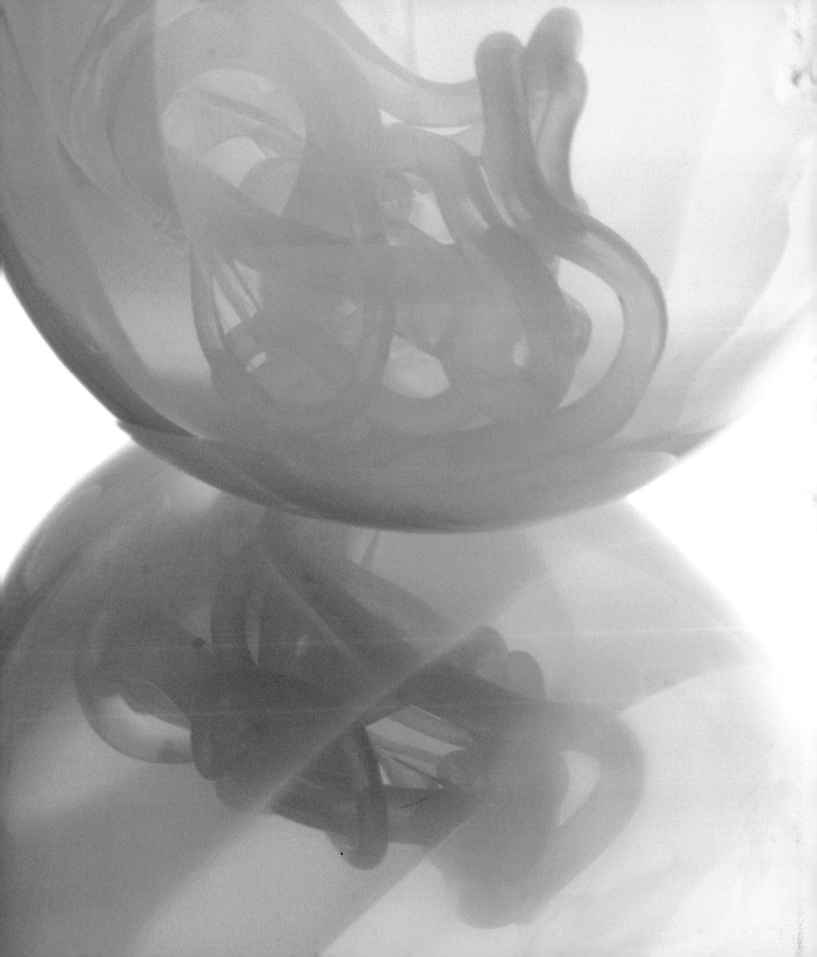

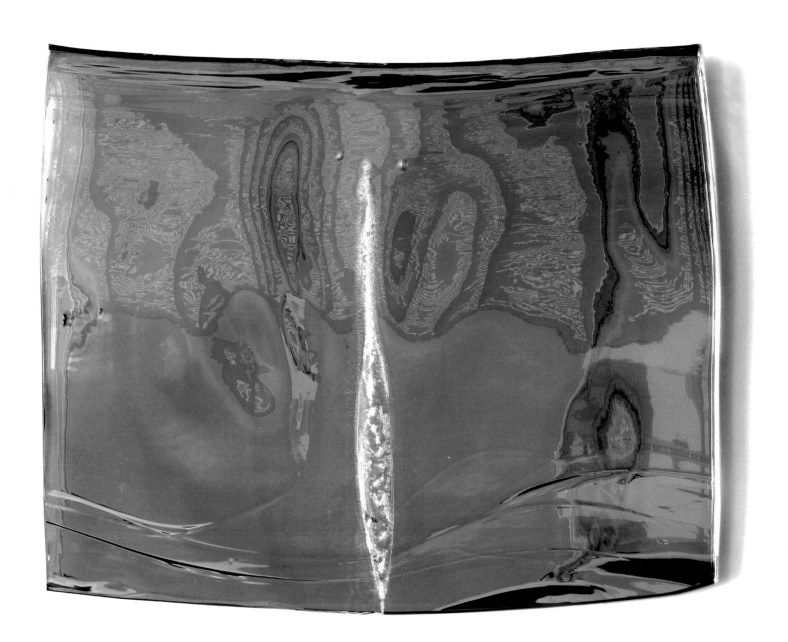

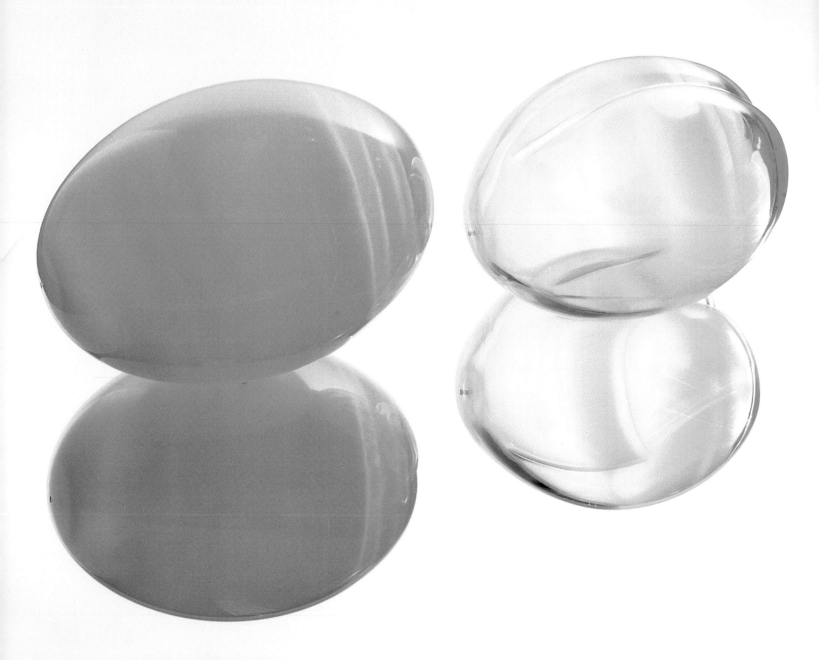

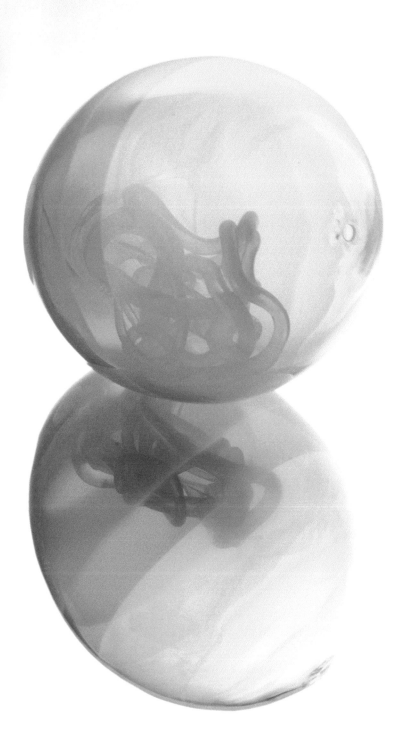

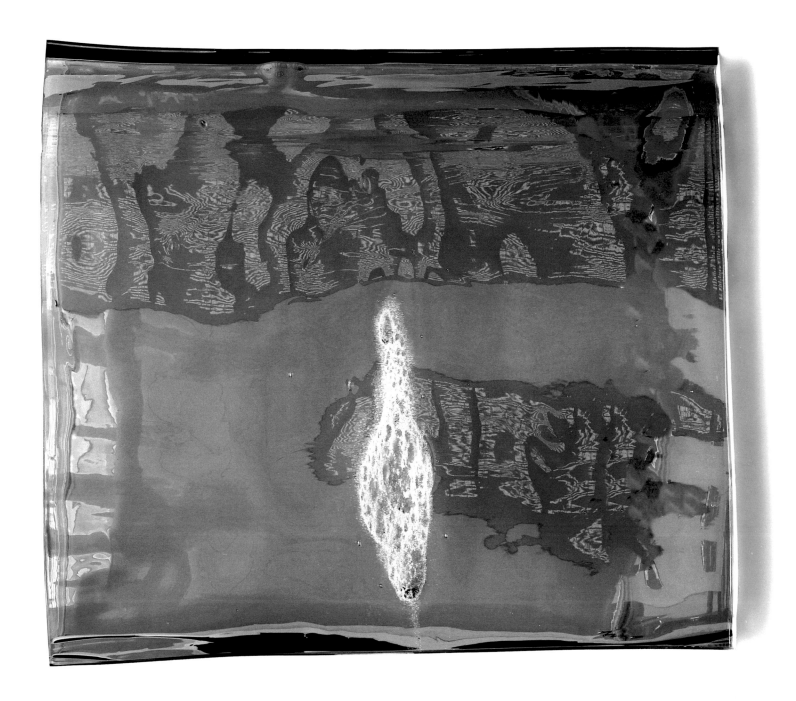

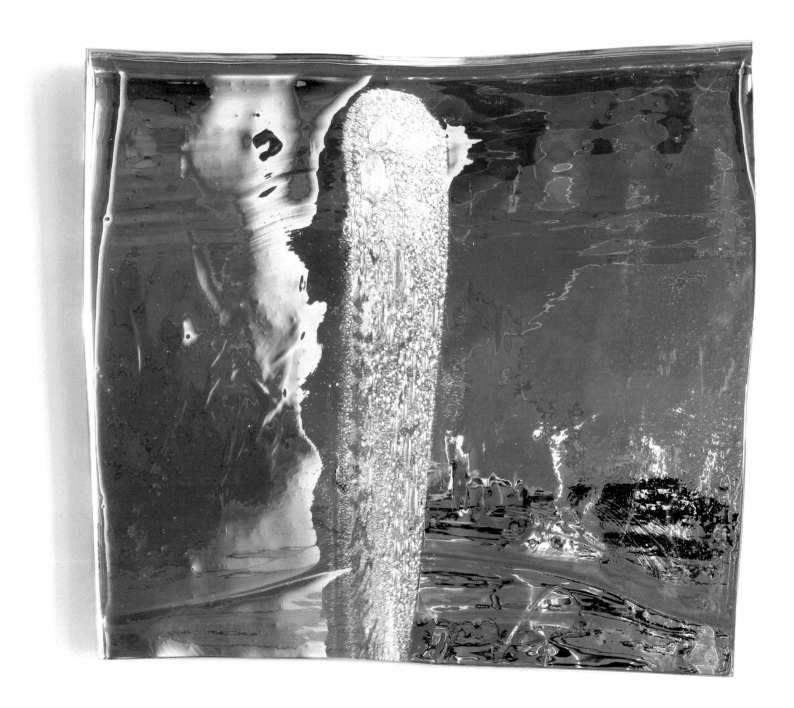

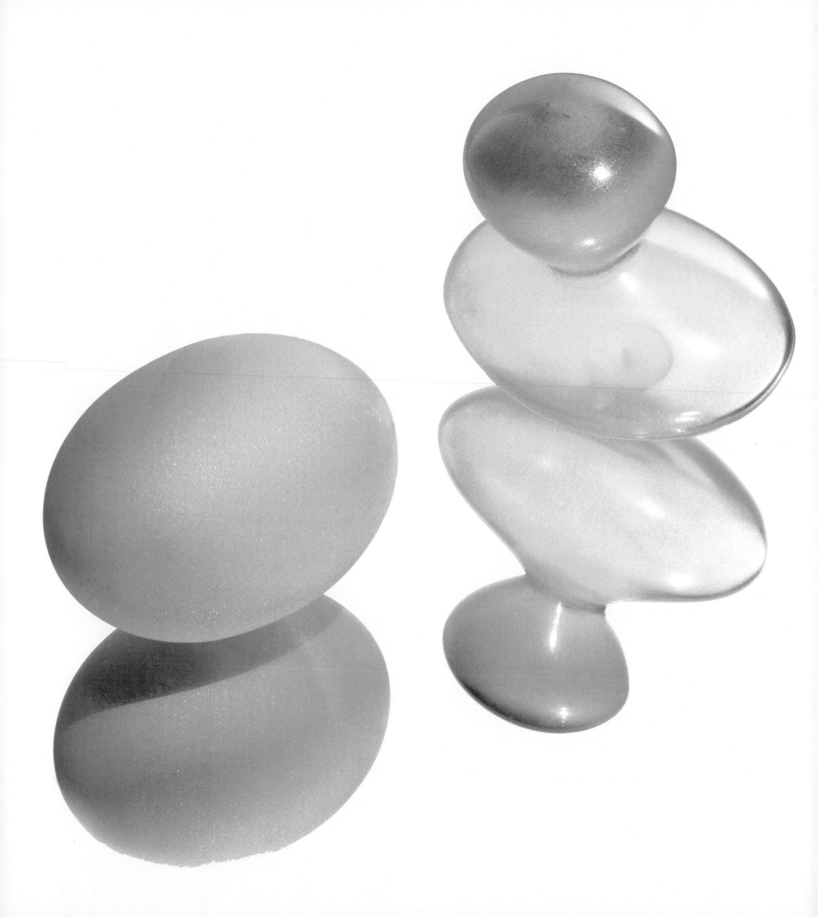

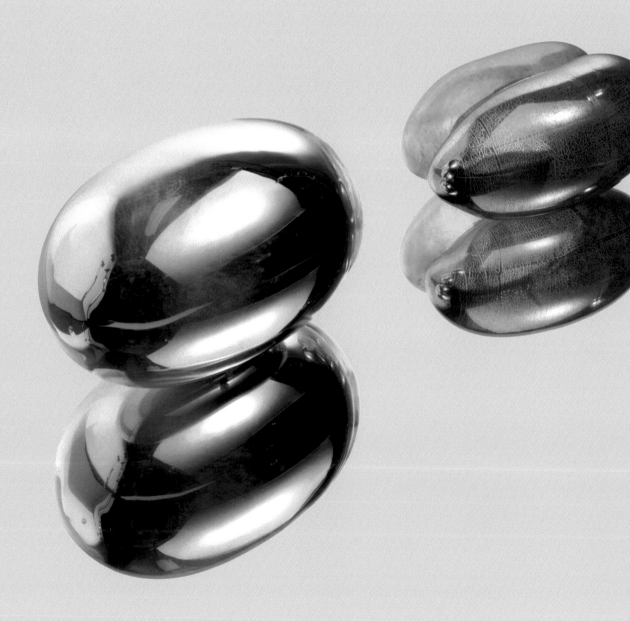

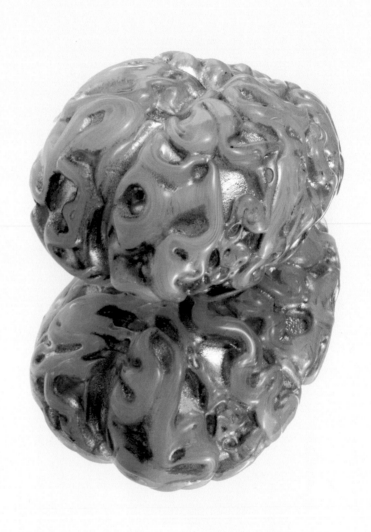

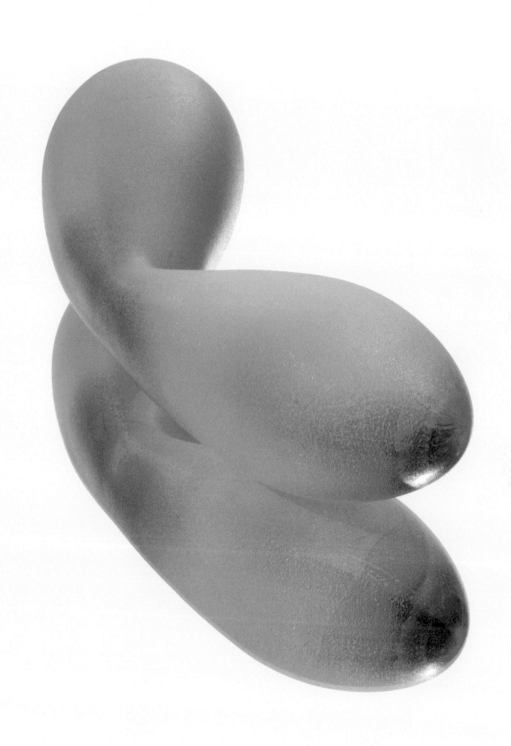

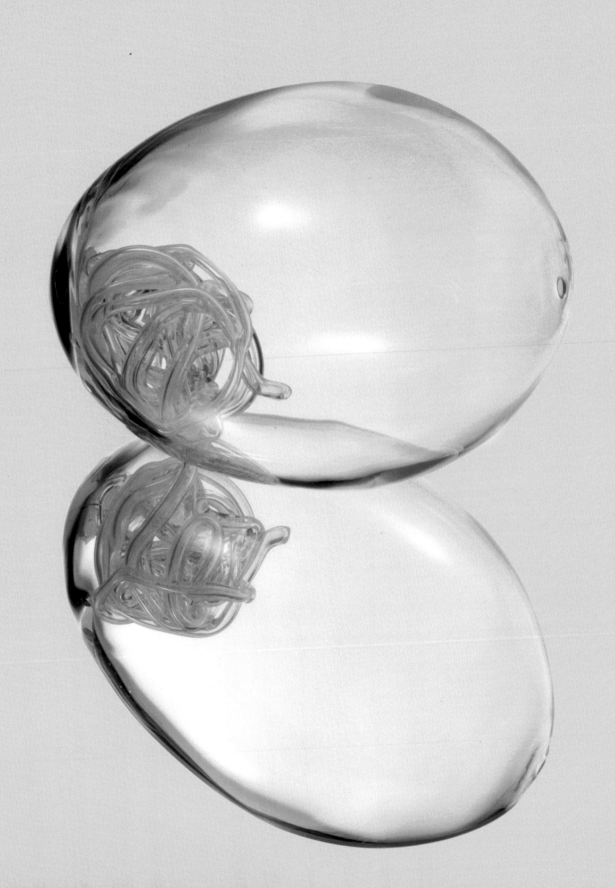

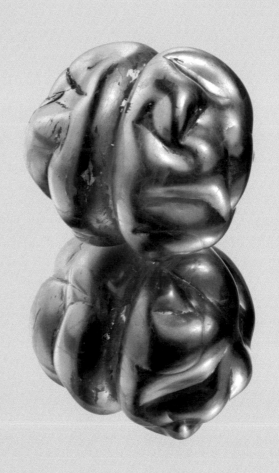

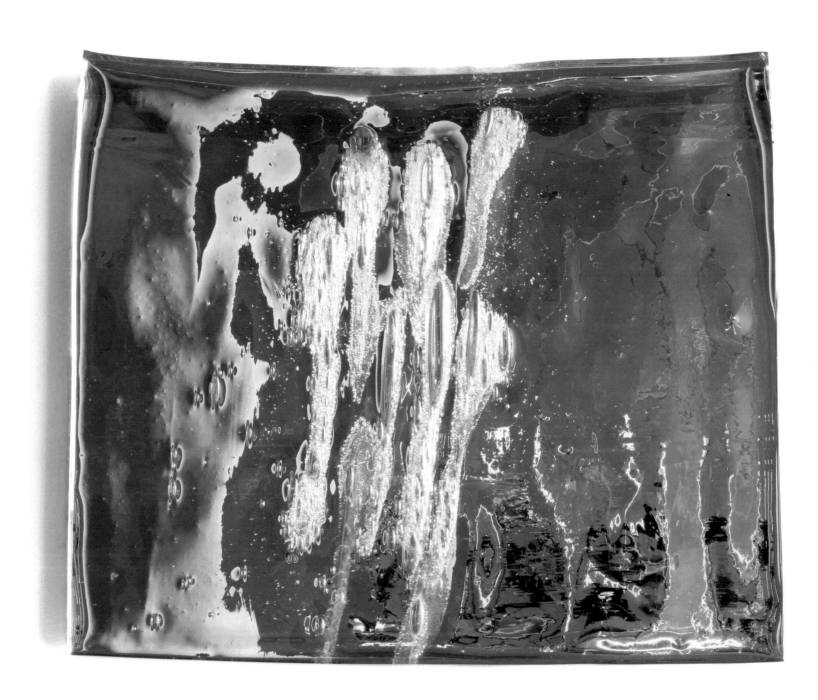

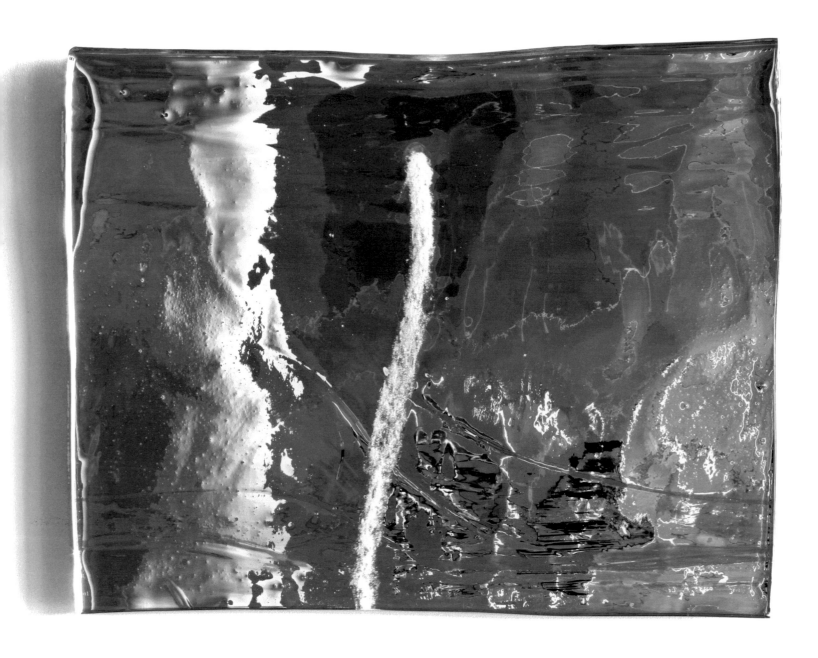

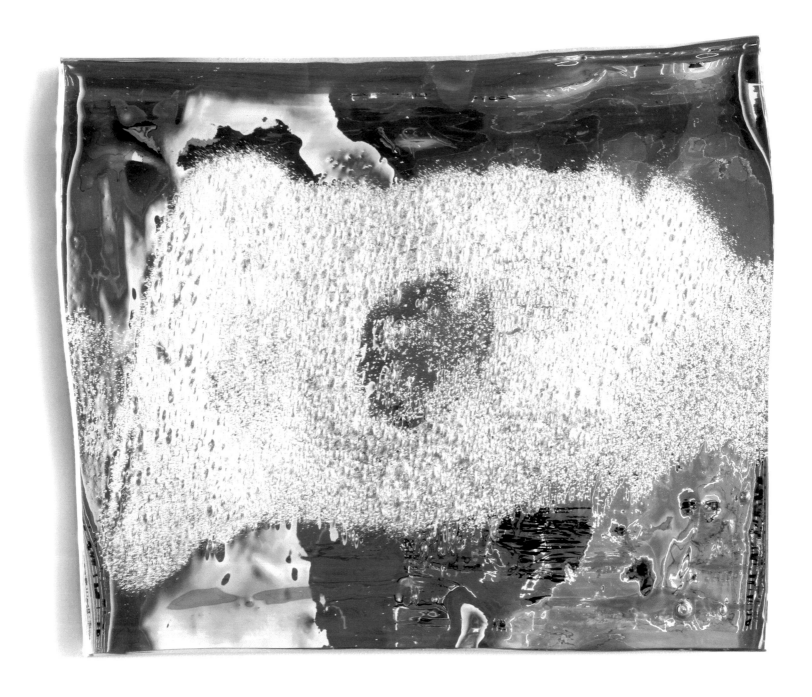

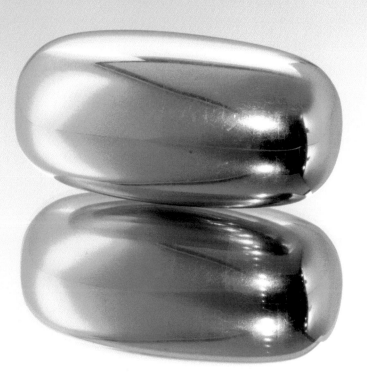

EARTH

(**Bhumi**) Produced from the splitting of space, Earth plays the role of mother in our world. As an element, it is the most humble and closest to the human level of reality, making it the easiest of the elements to perceive. Earth is the basis of the great world upon which we stand, and it manifests in sacred mountains, such as Mount Kailsasa in the Himalayas. Kailsasa is considered the home of the god Shiva and his wife Parvati, and their union represents and reenacts the union of male and female energy in the universe. This union is depicted in abstract form by means of a masculine lingam rising out of a female base, or yoni.

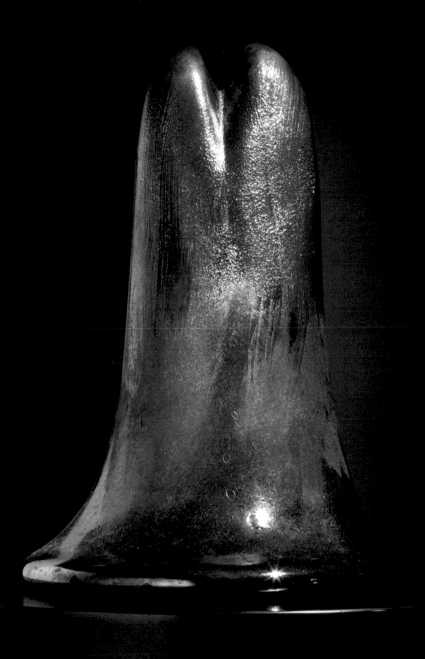

44

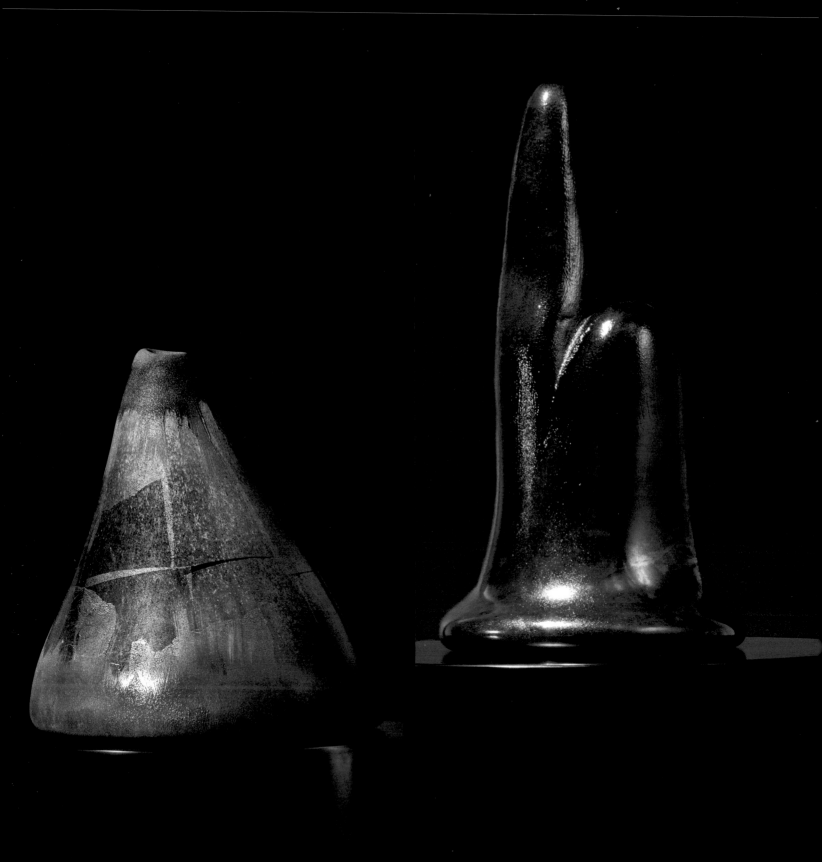

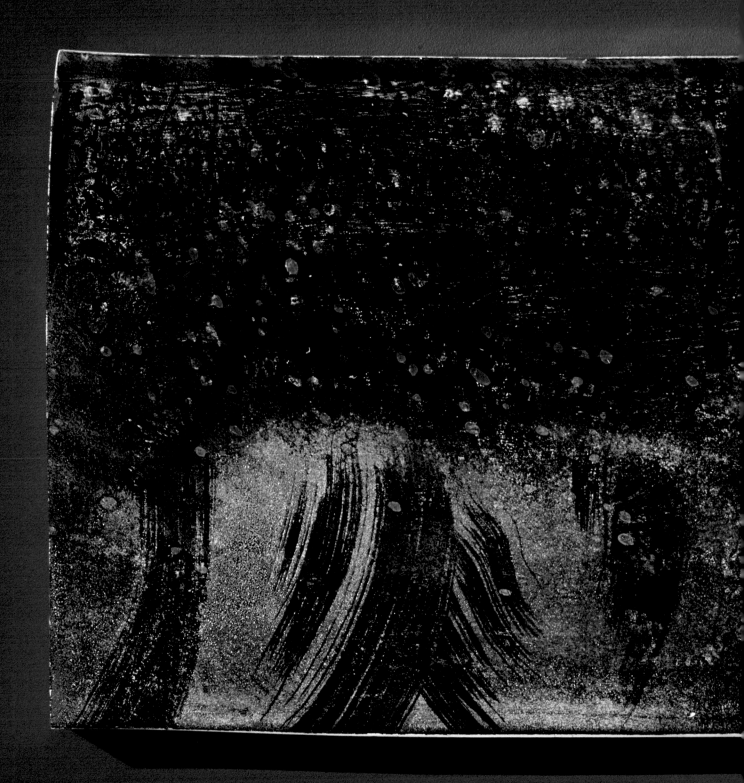

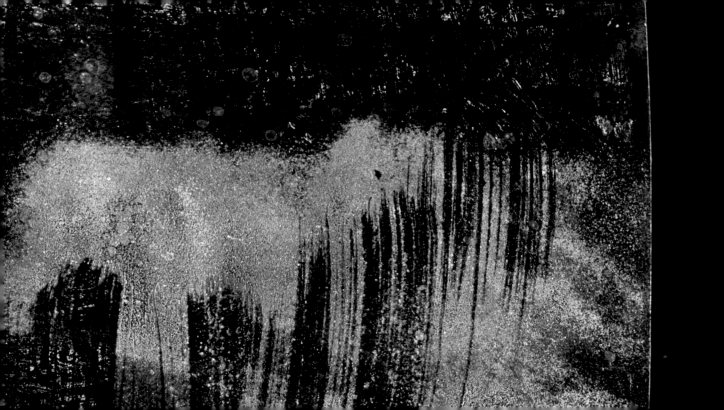

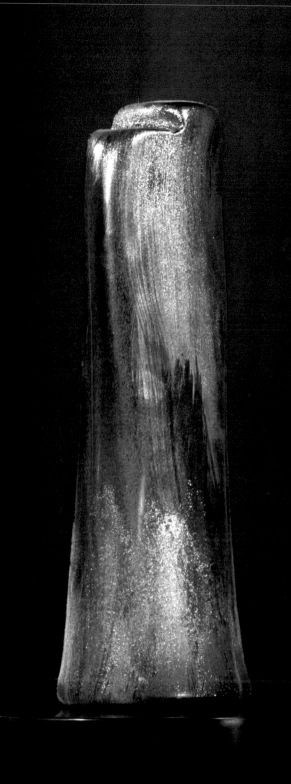

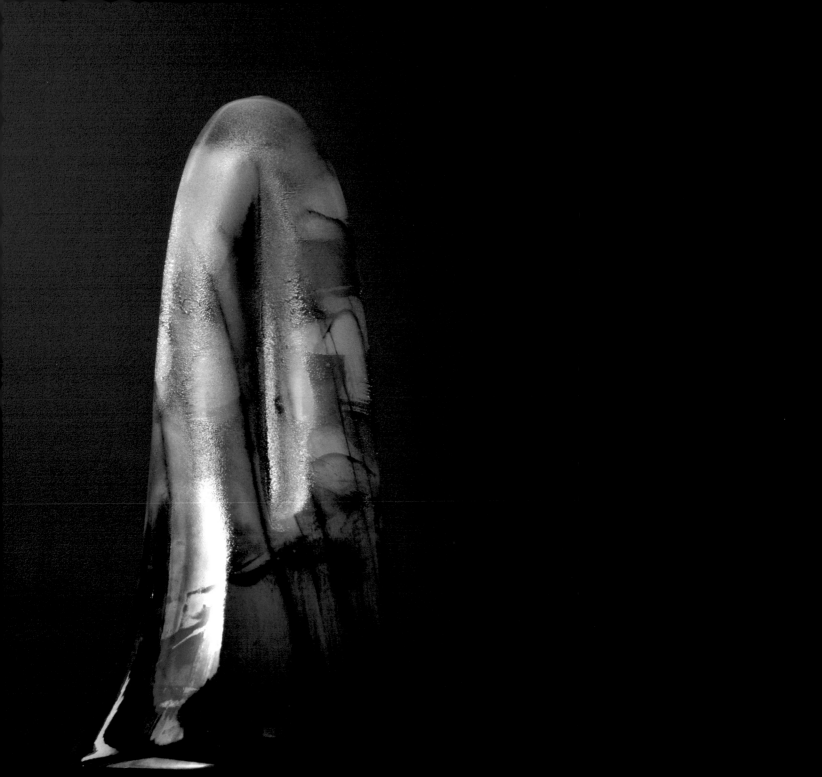

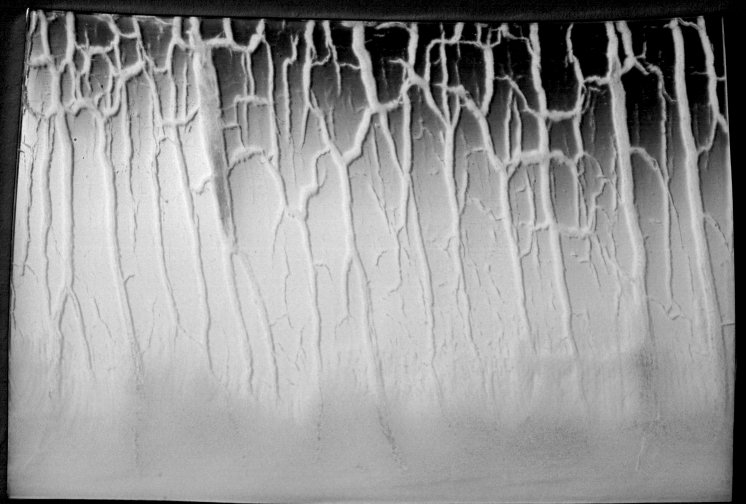

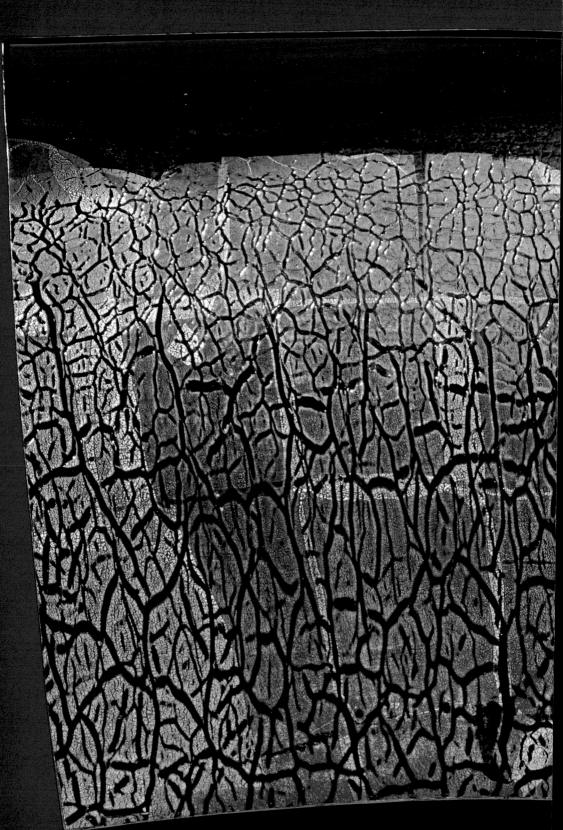

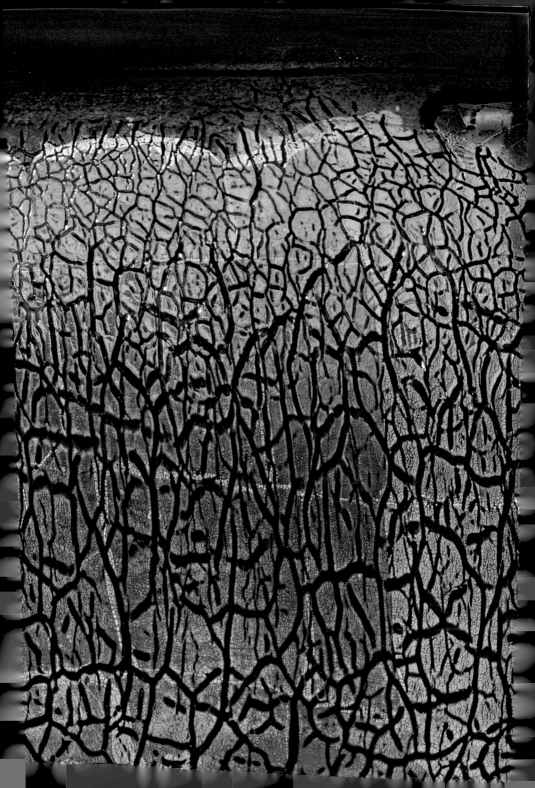

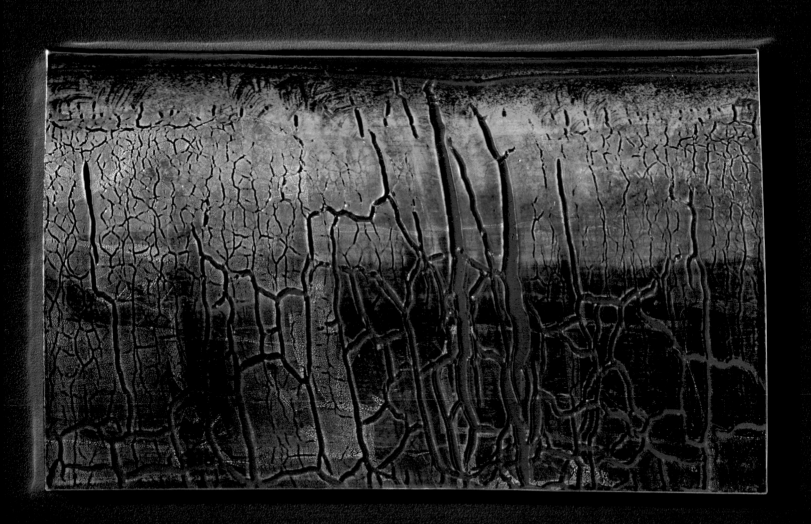

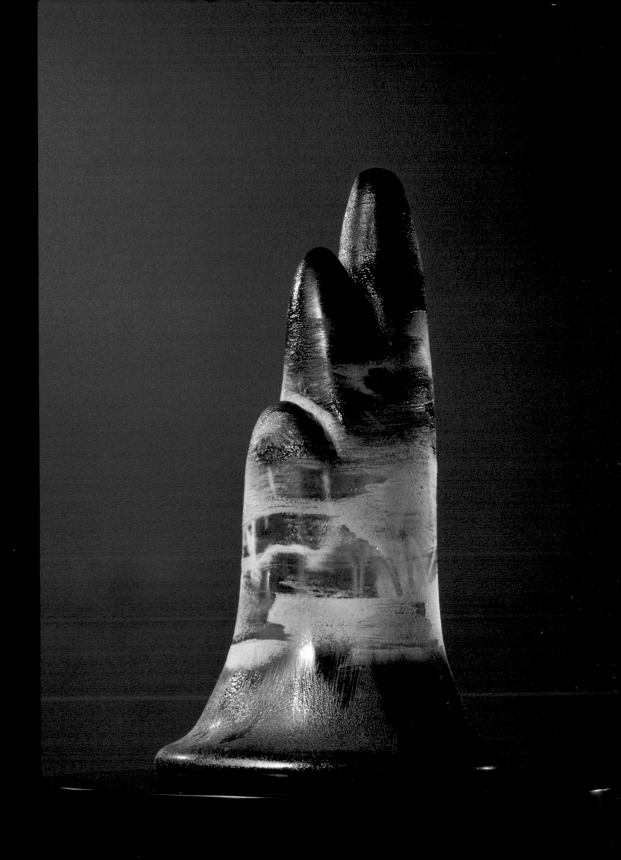

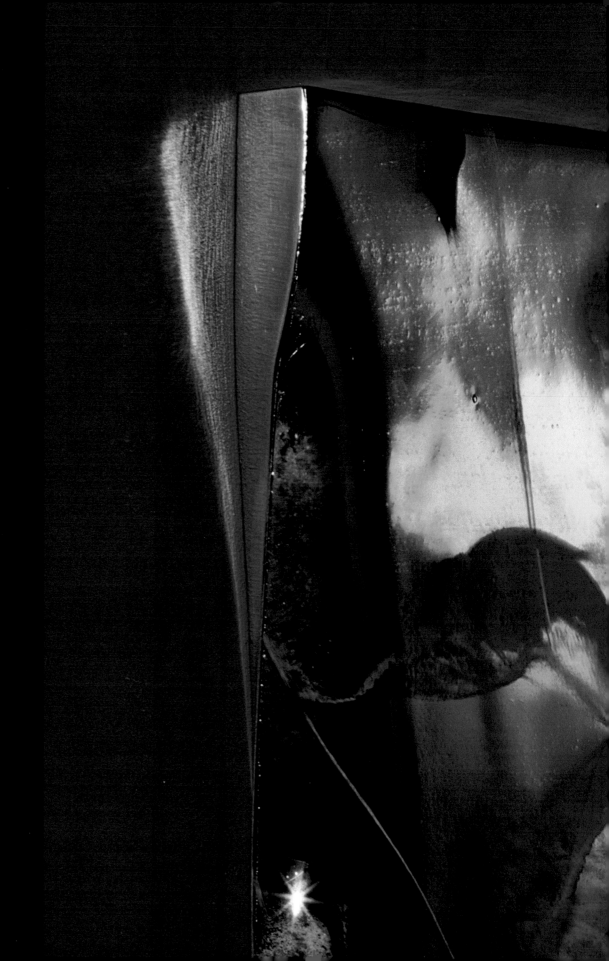

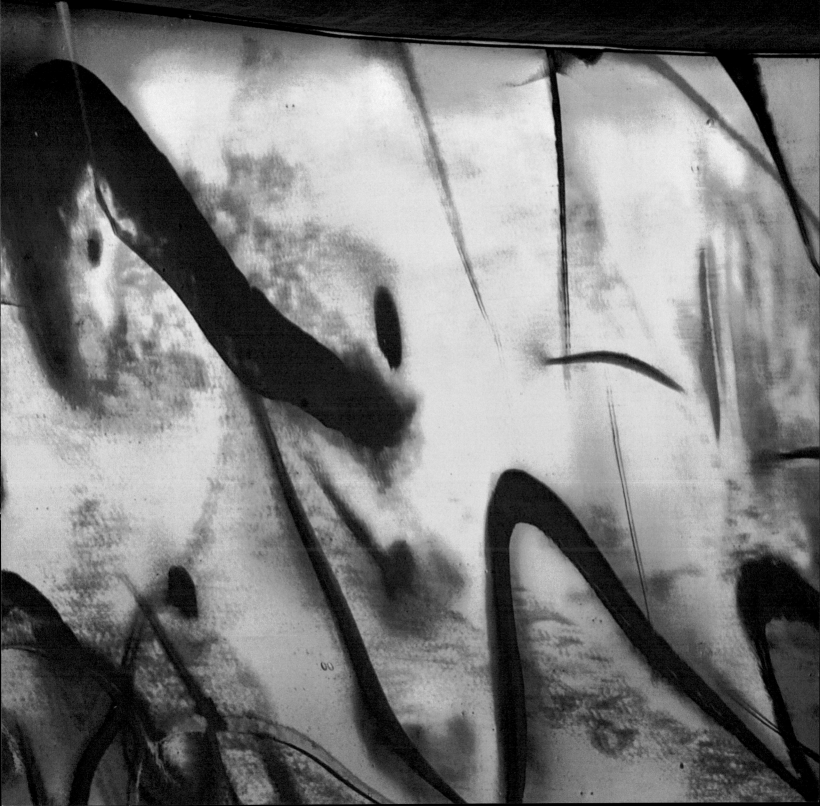

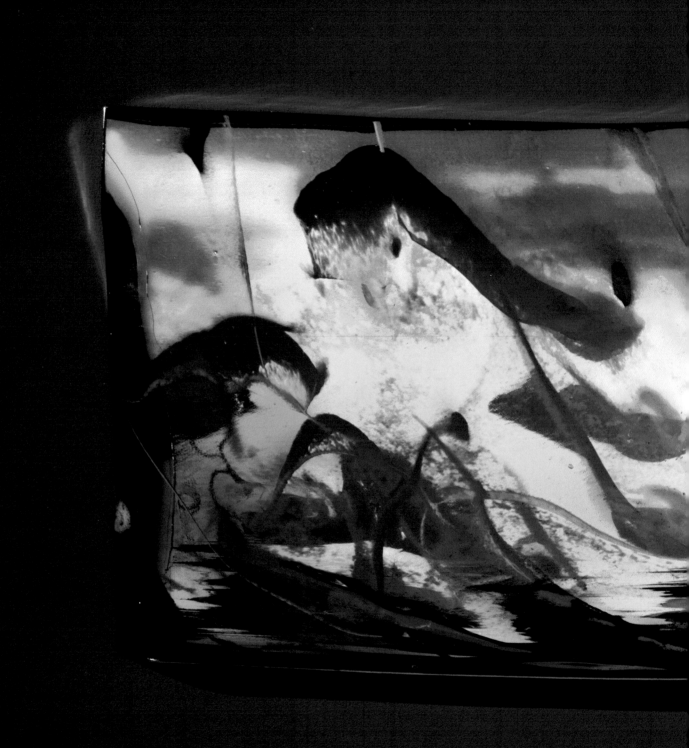

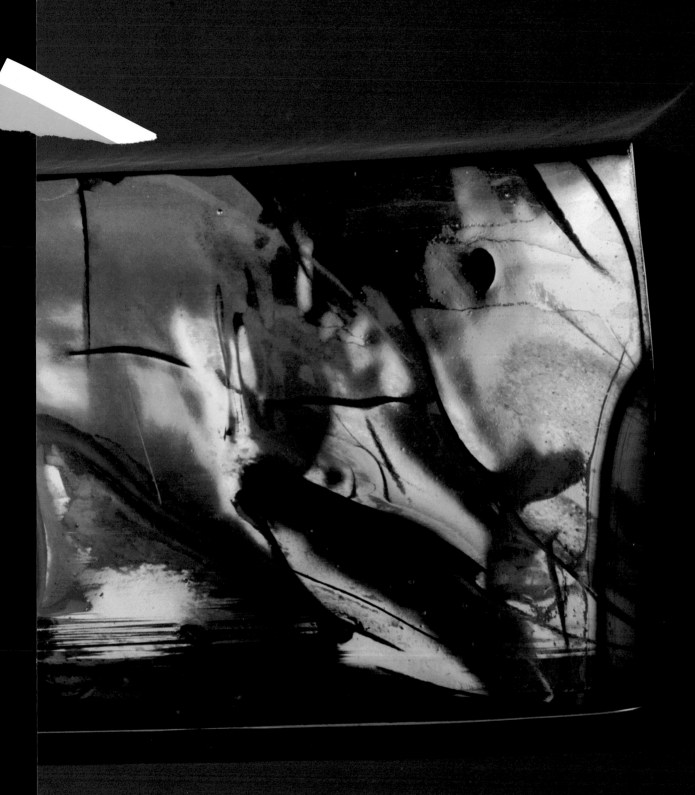

SUN

(Surya) The Sun, the supreme light, is produced from primordial Space as Earth is. The Sun is the giver of life and the ruler of the planets of the solar system. It is

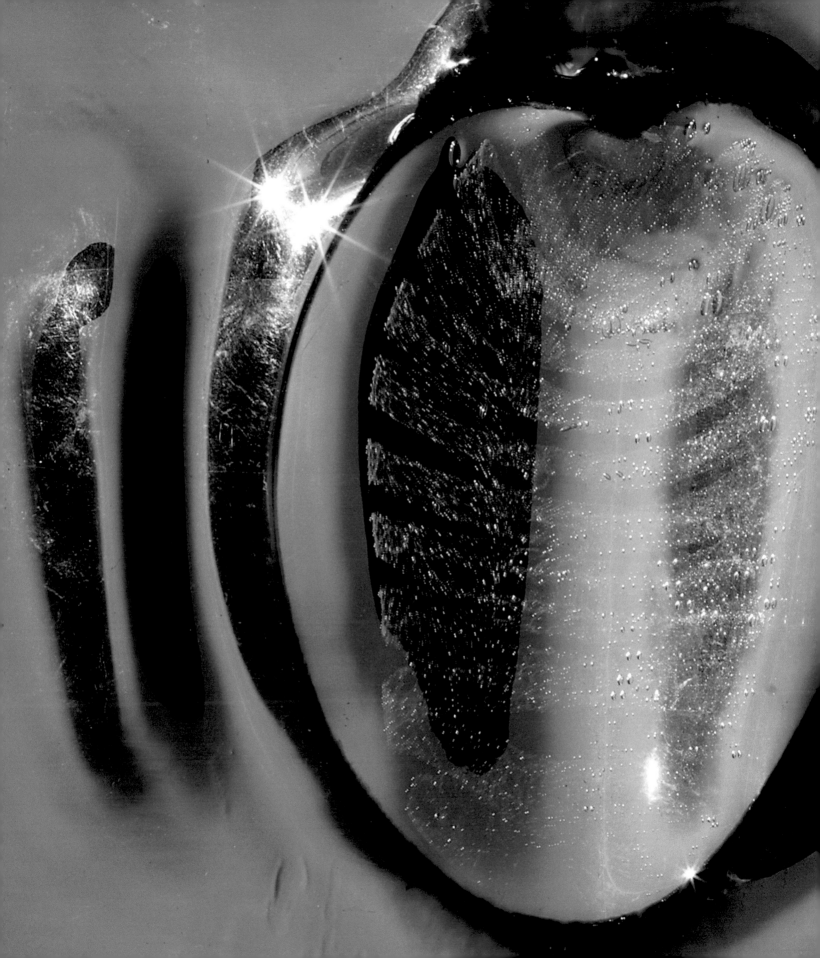

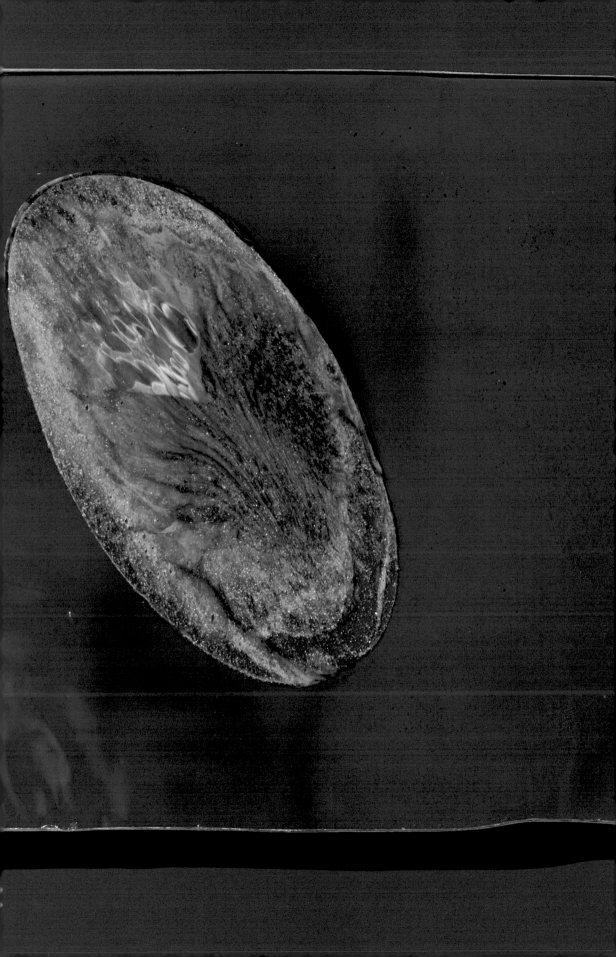

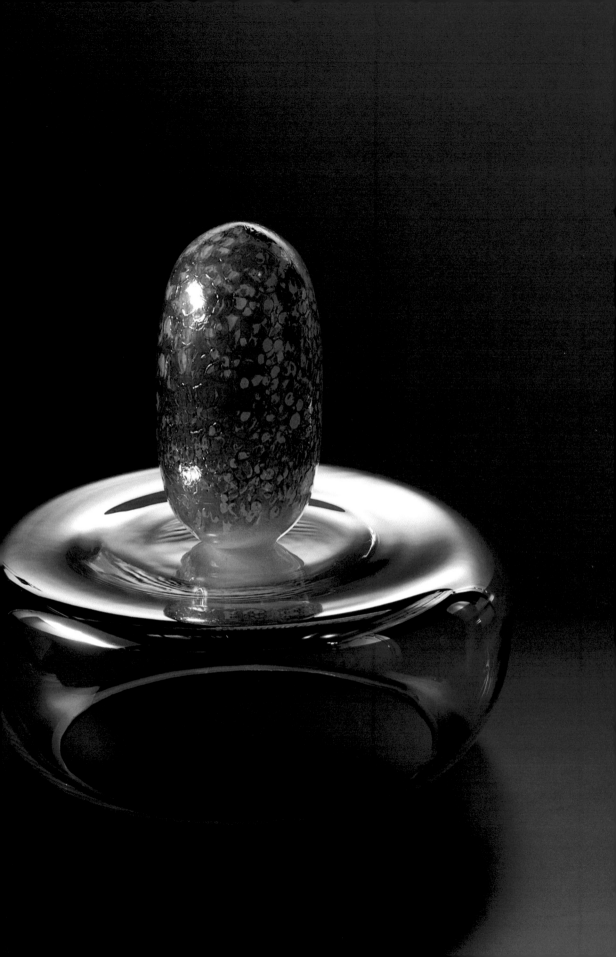

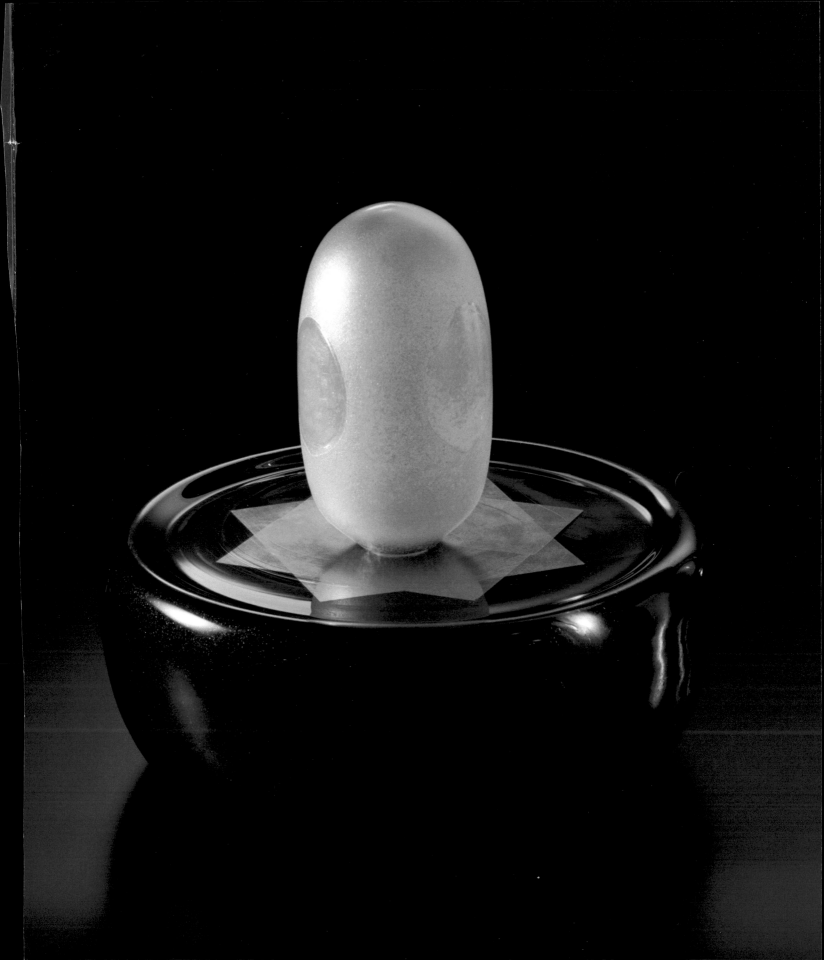

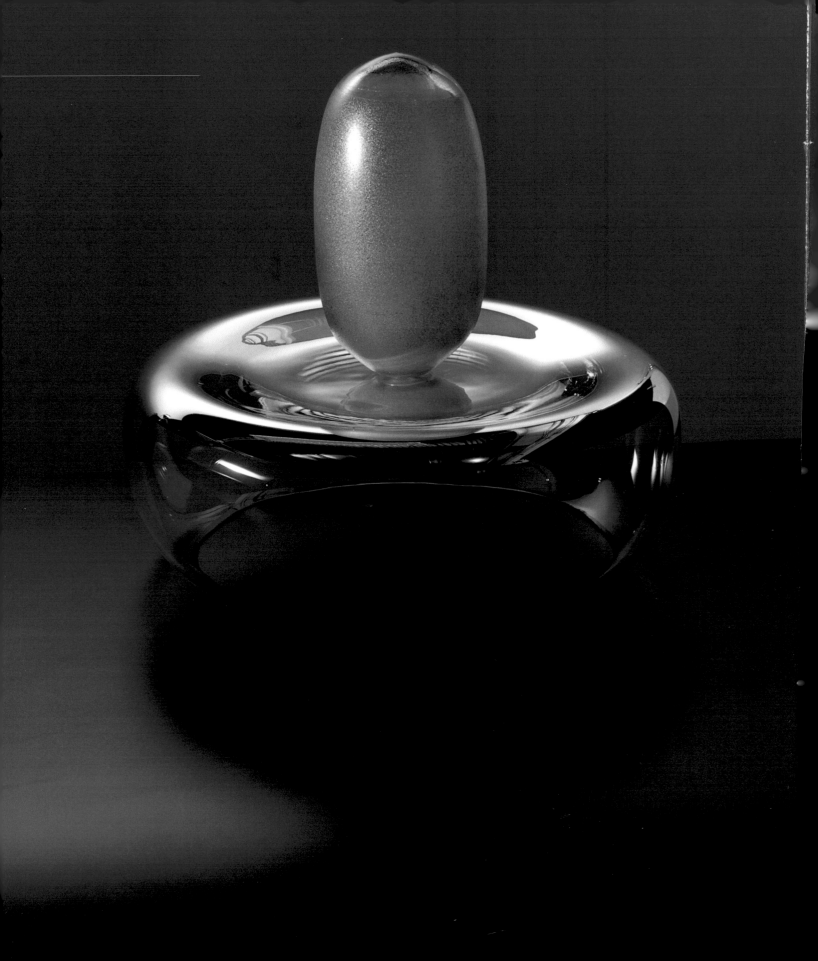

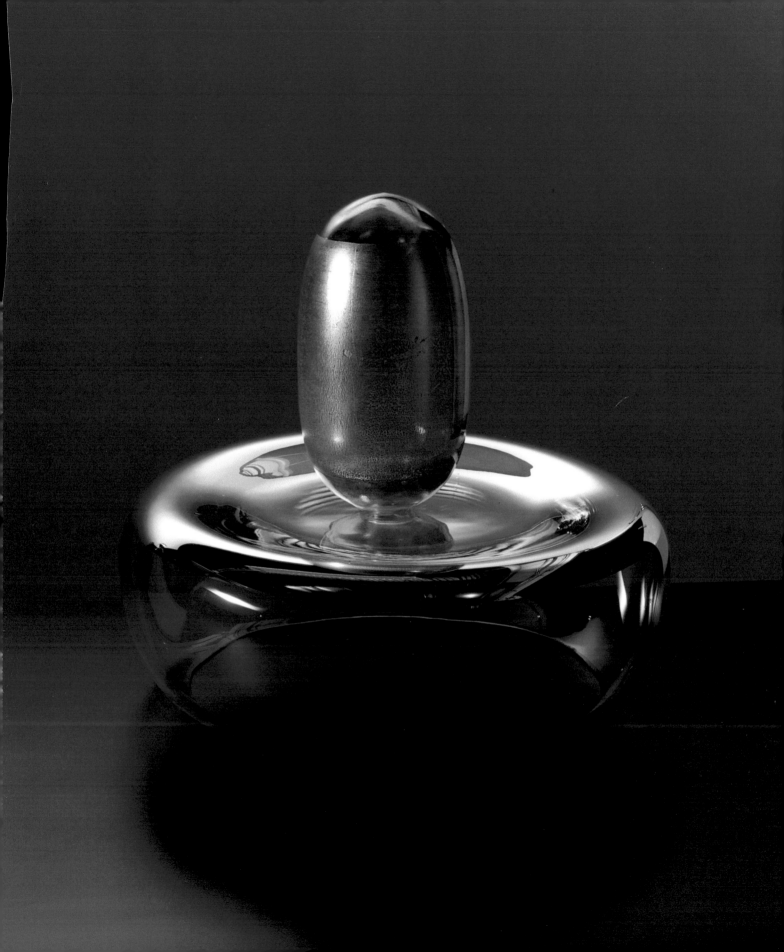

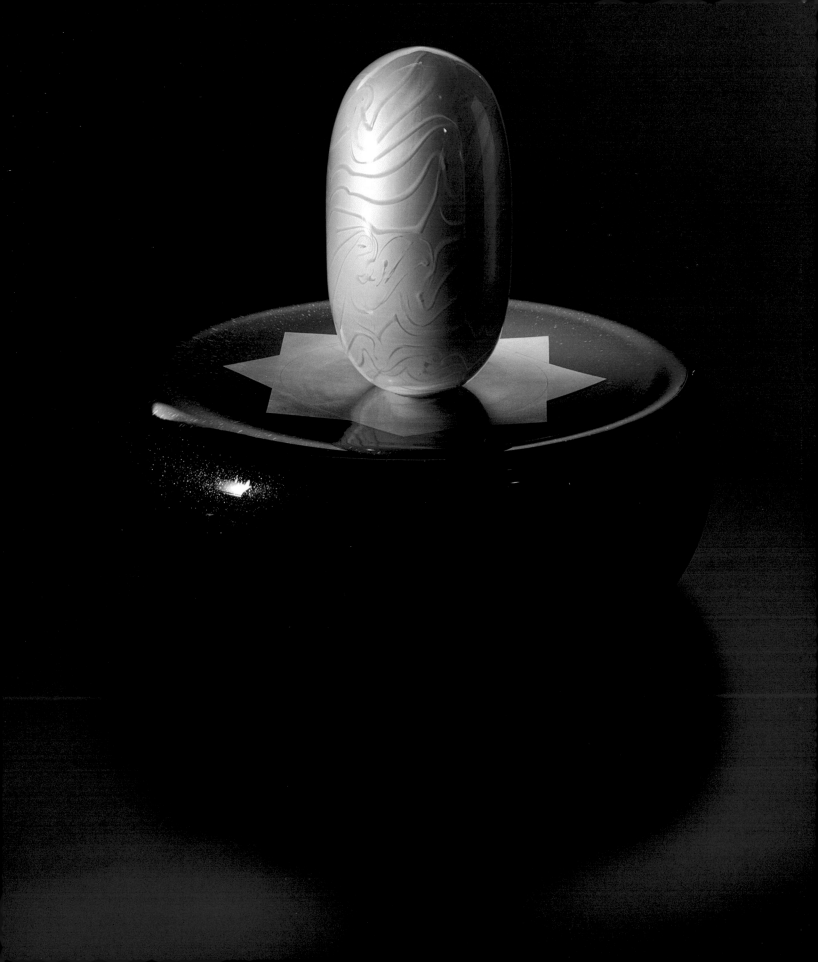

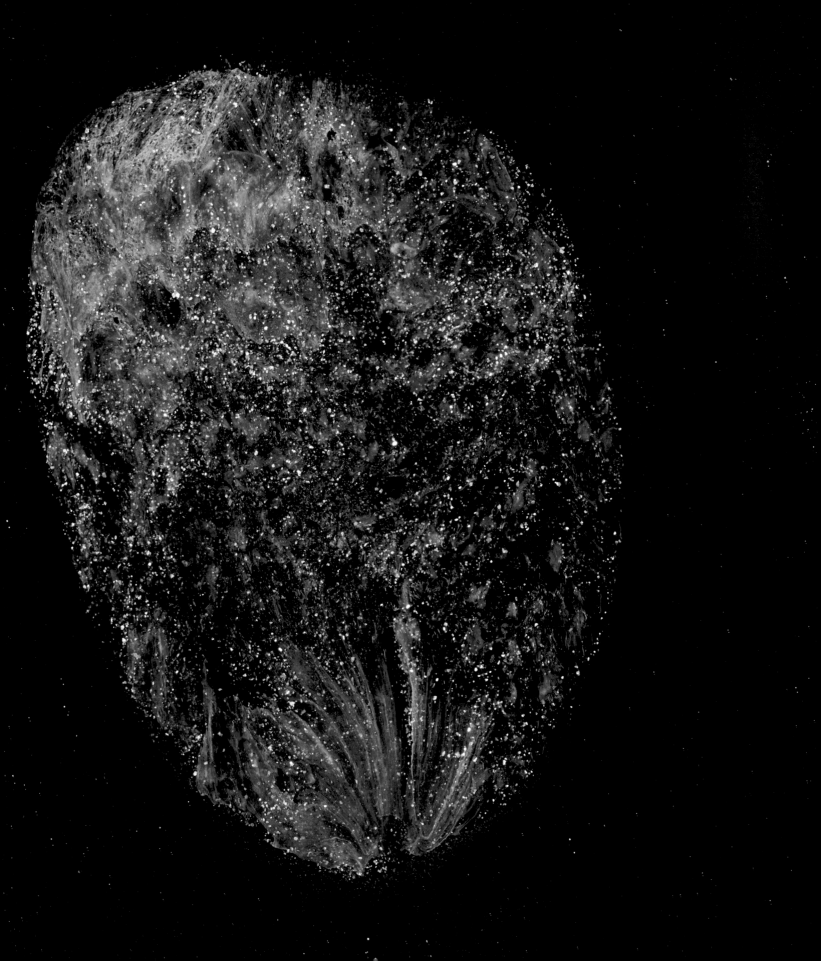

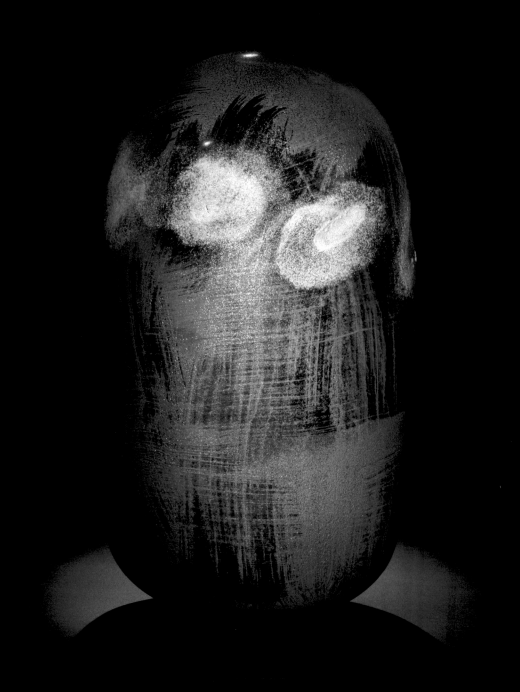

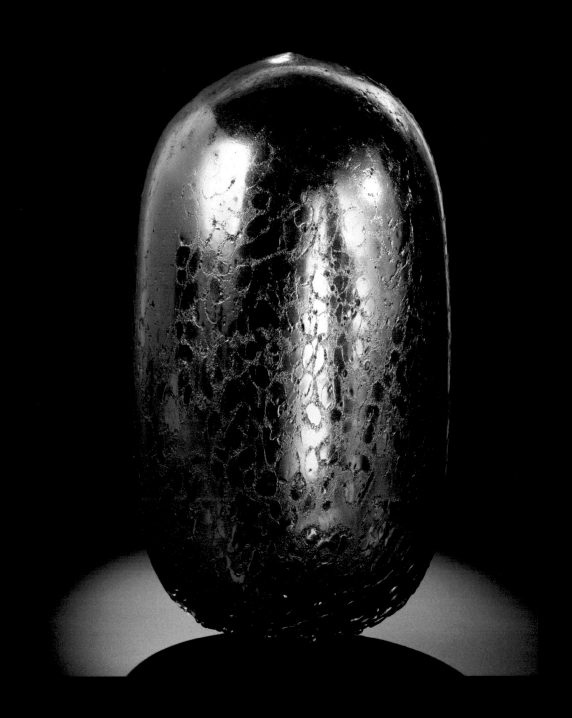

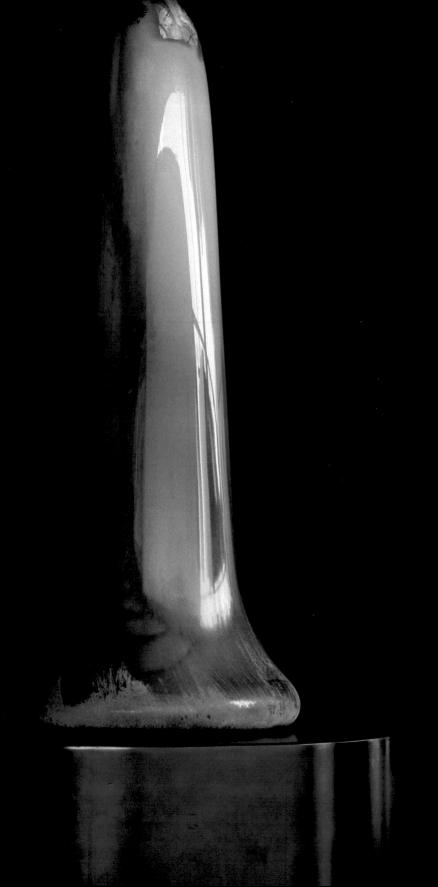

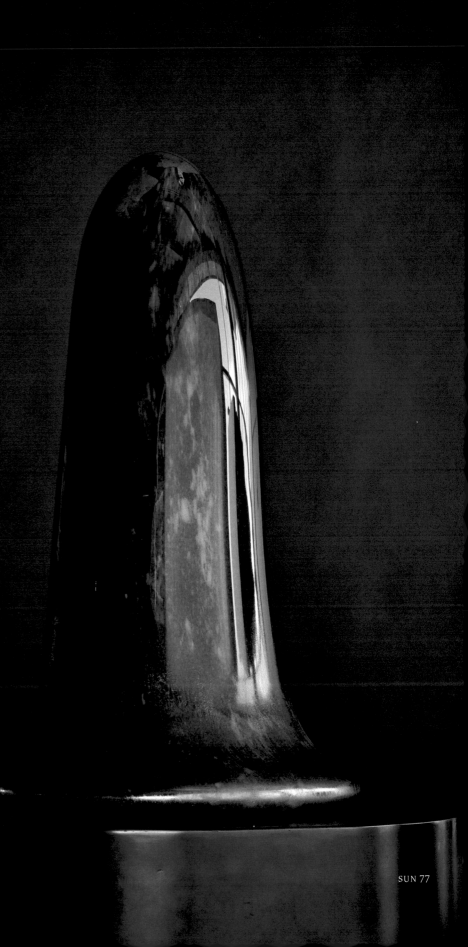

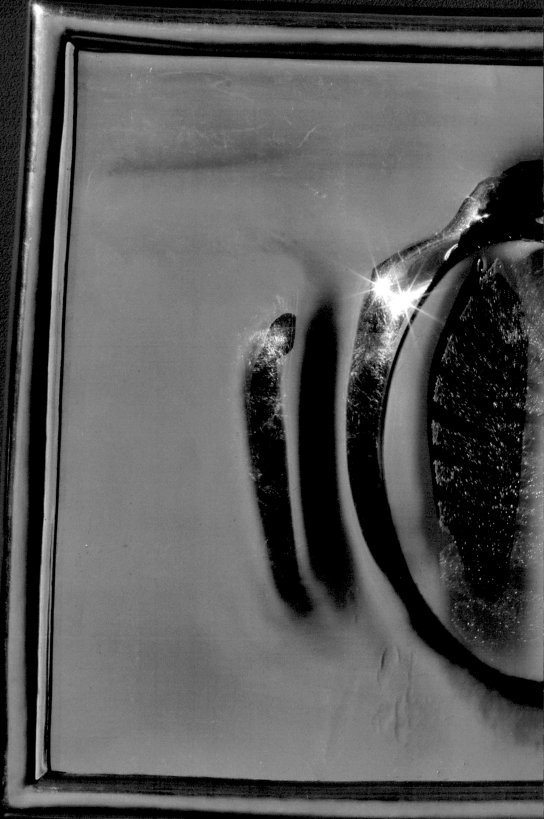

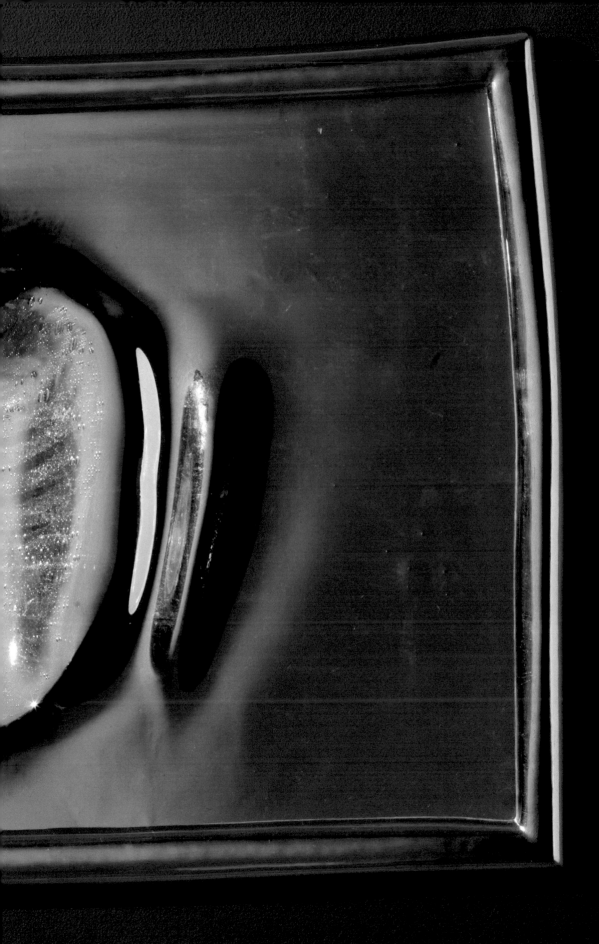

MOON
AND
CONSTELLATIONS

(**Candra and Nakshatra**) The Moon was the first thing produced during the splitting of the primordial egg, and it rose out of the milky ocean of chaos. The disk of the Moon is the master of the stars and of medicine; it is the source of *amrita*, the nectar of immortality, and its cooling light gives life. The Moon and the Constellations are intimately connected, as the Moon is the husband of the Constellations. As the Constellations move through space and interact with cosmic bodies, they also exert their influence on the actions of human bodies.

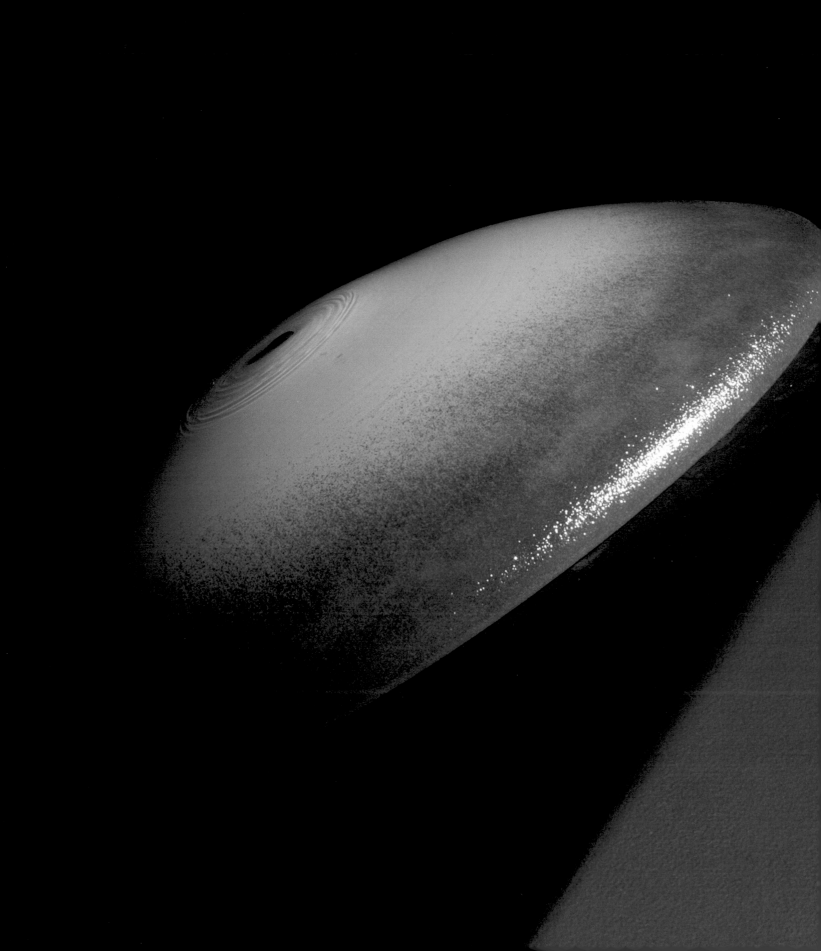

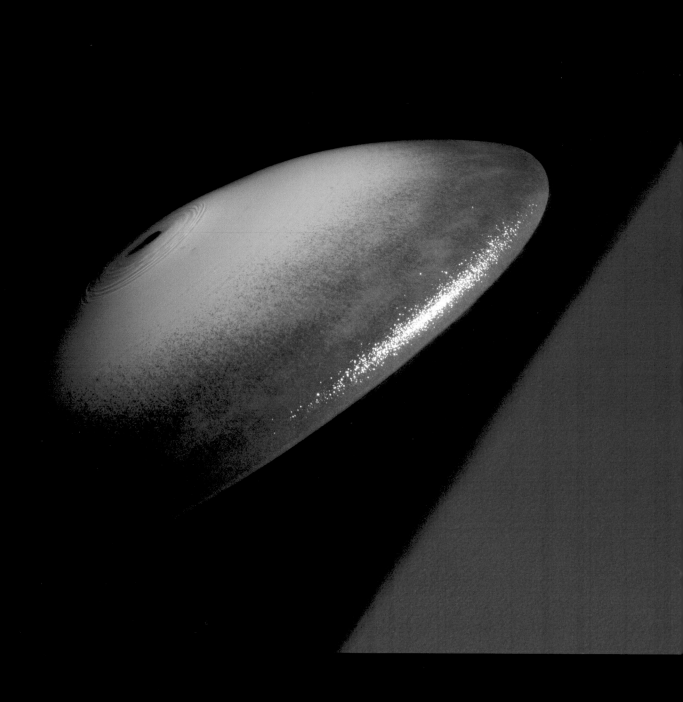

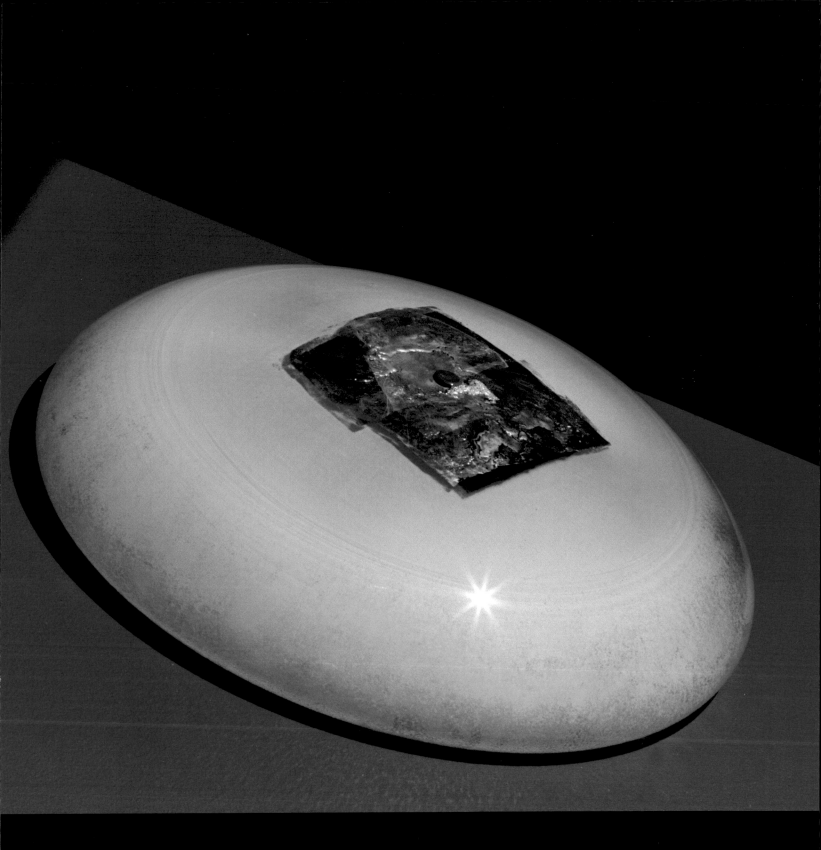

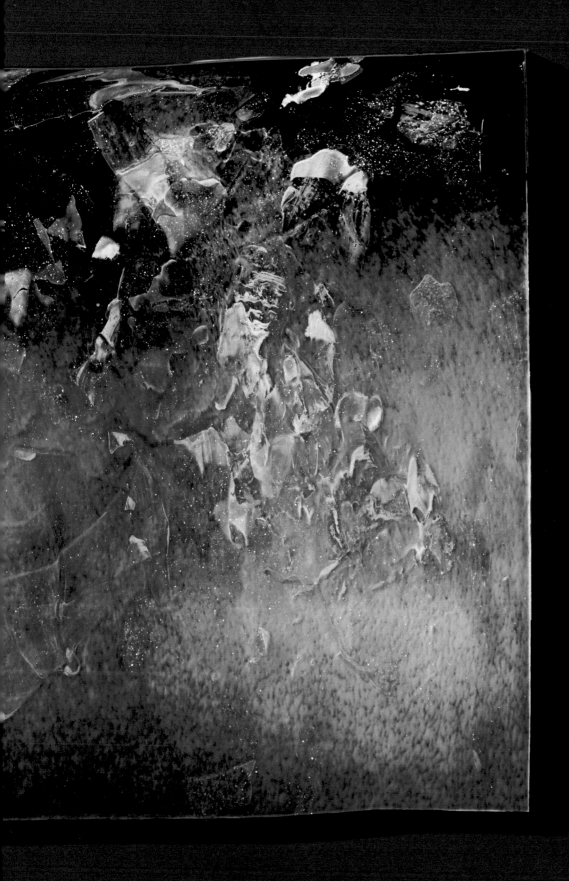

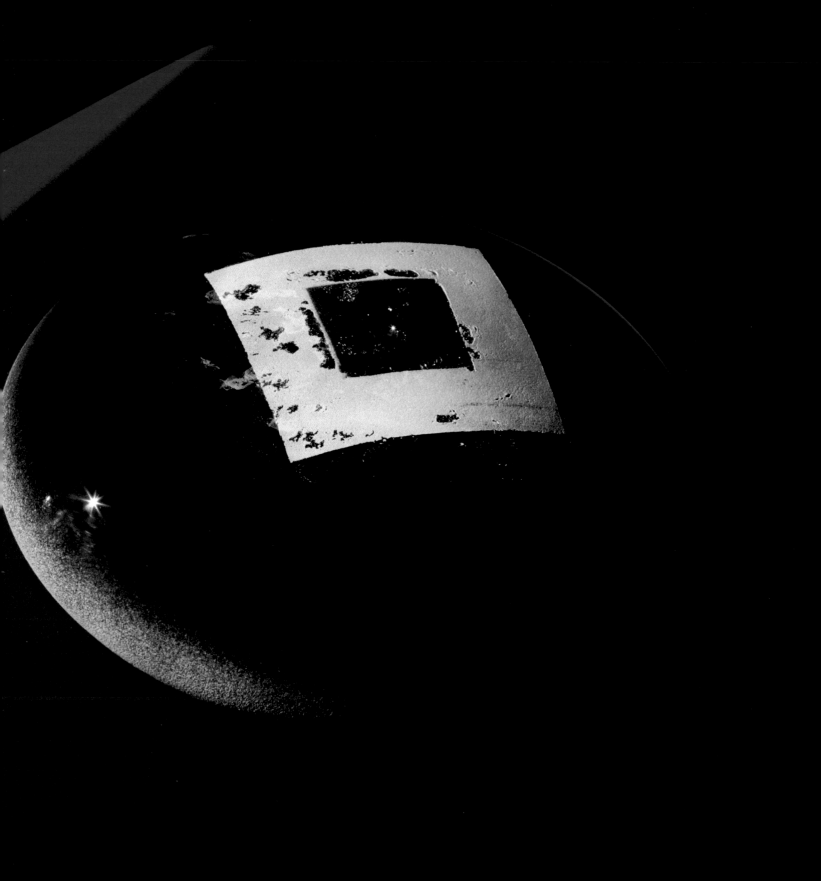

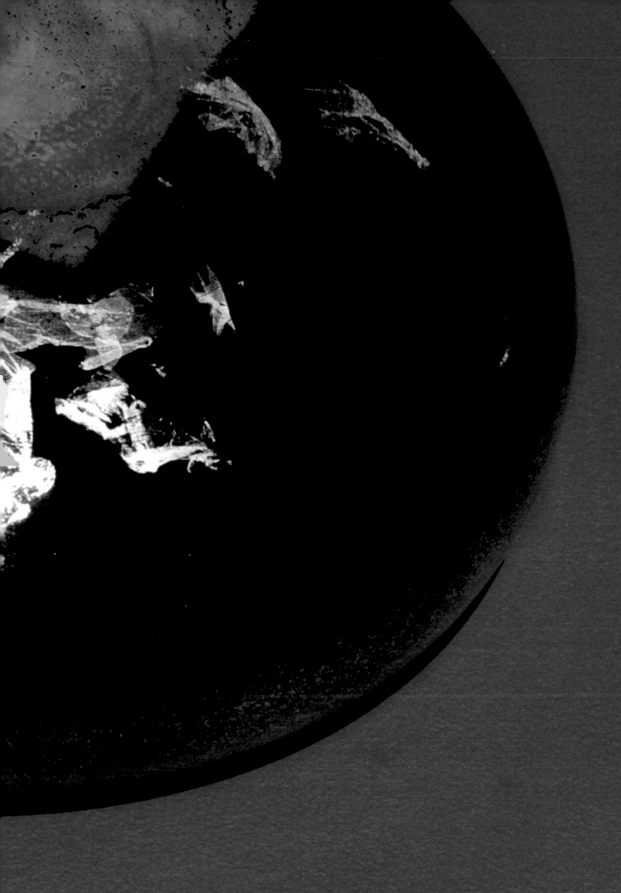

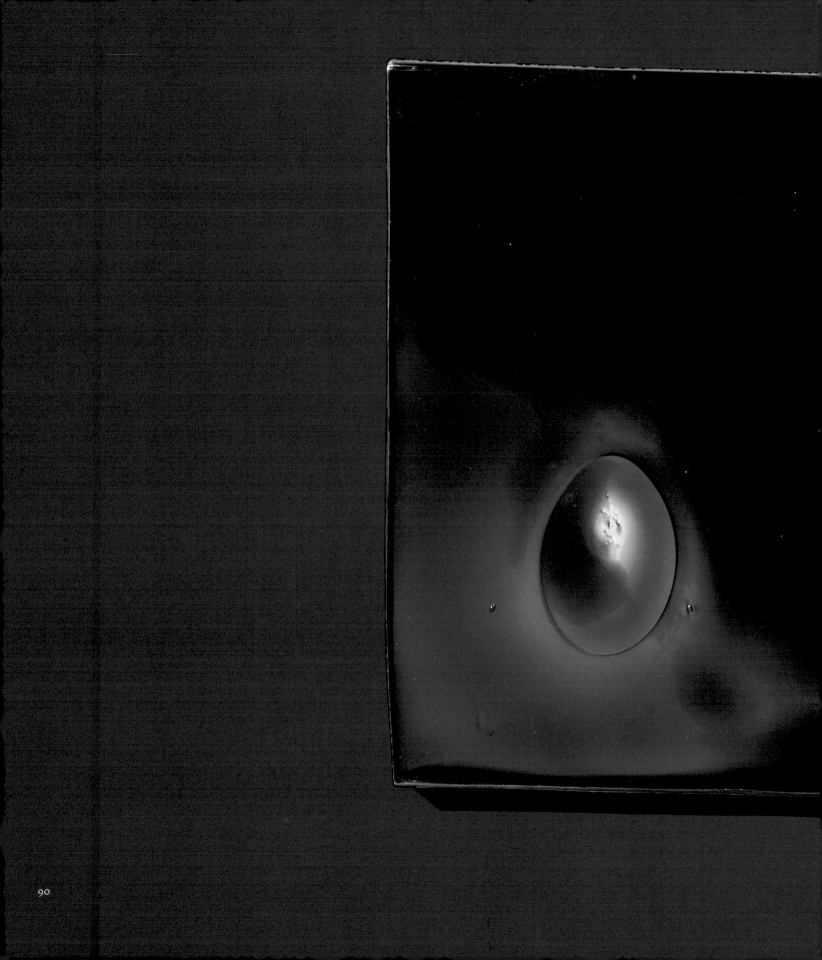

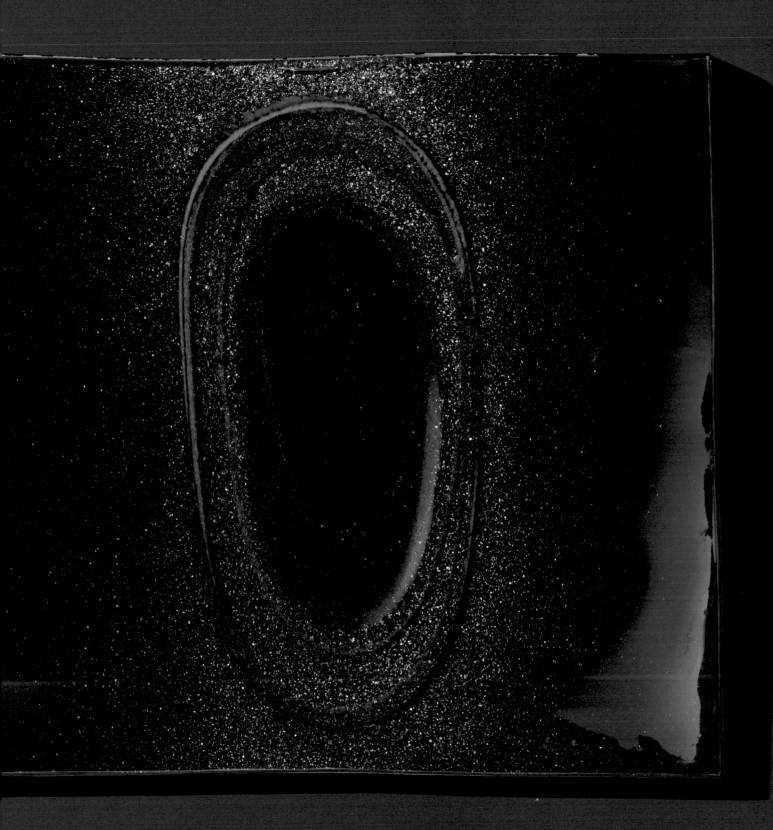

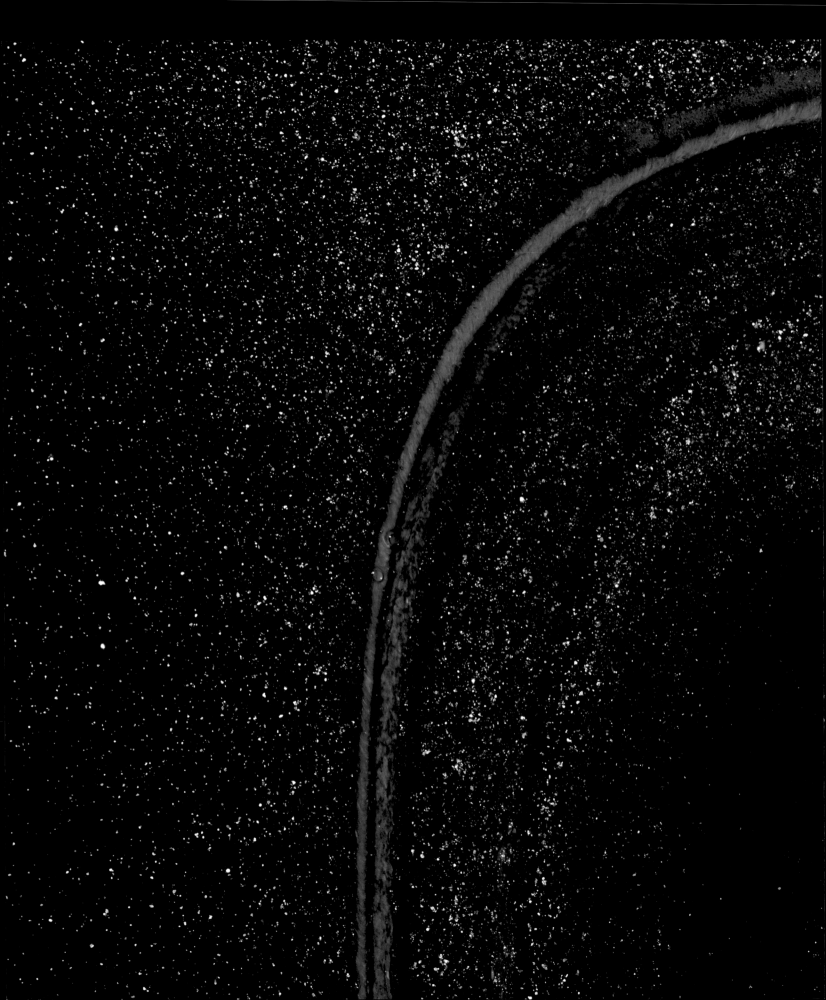

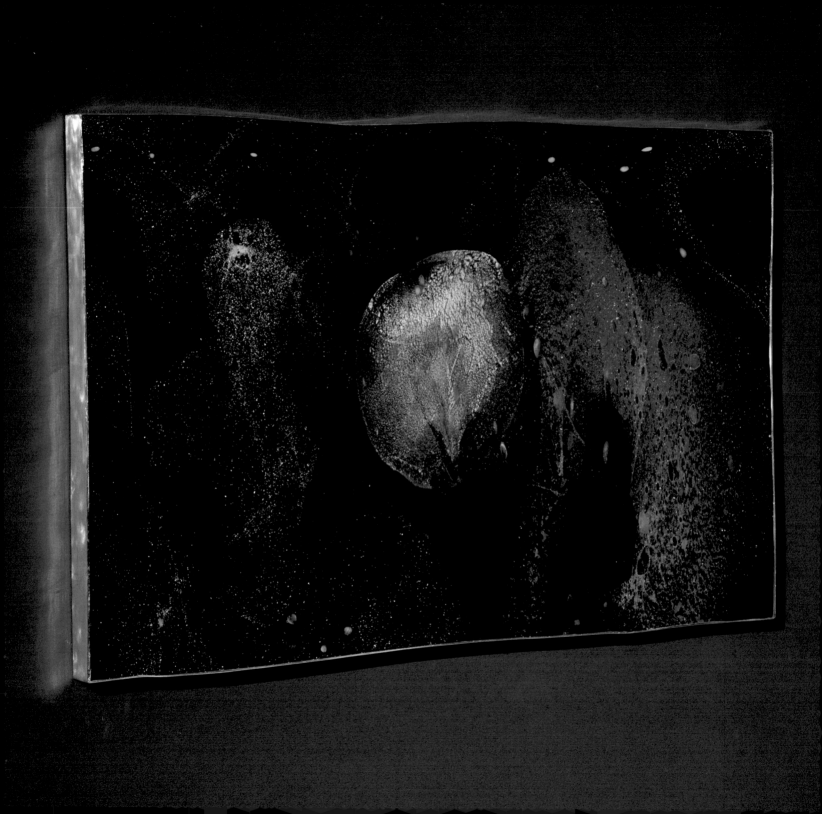

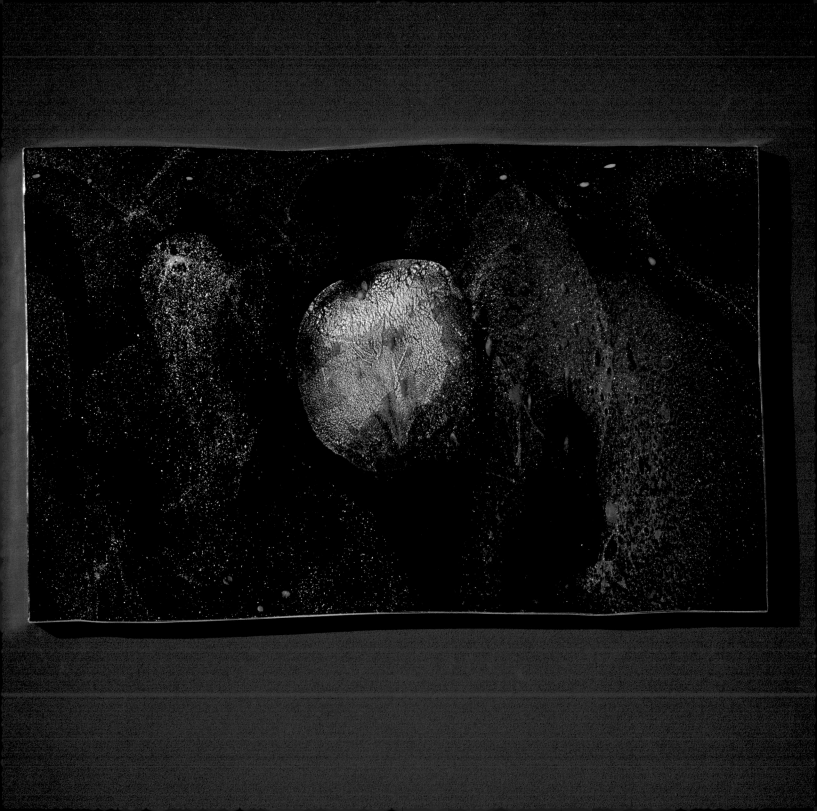

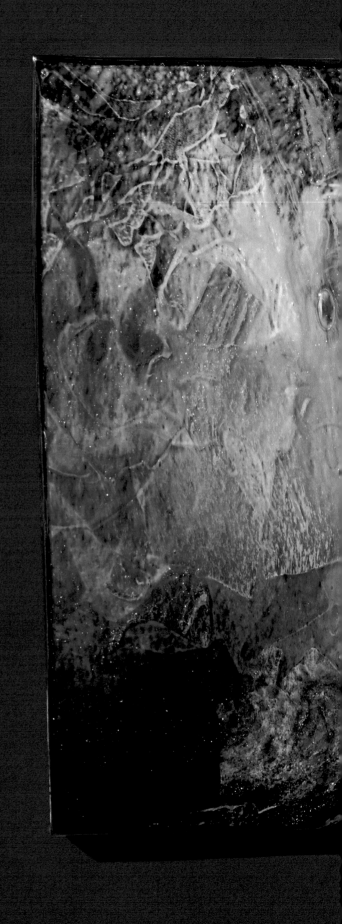

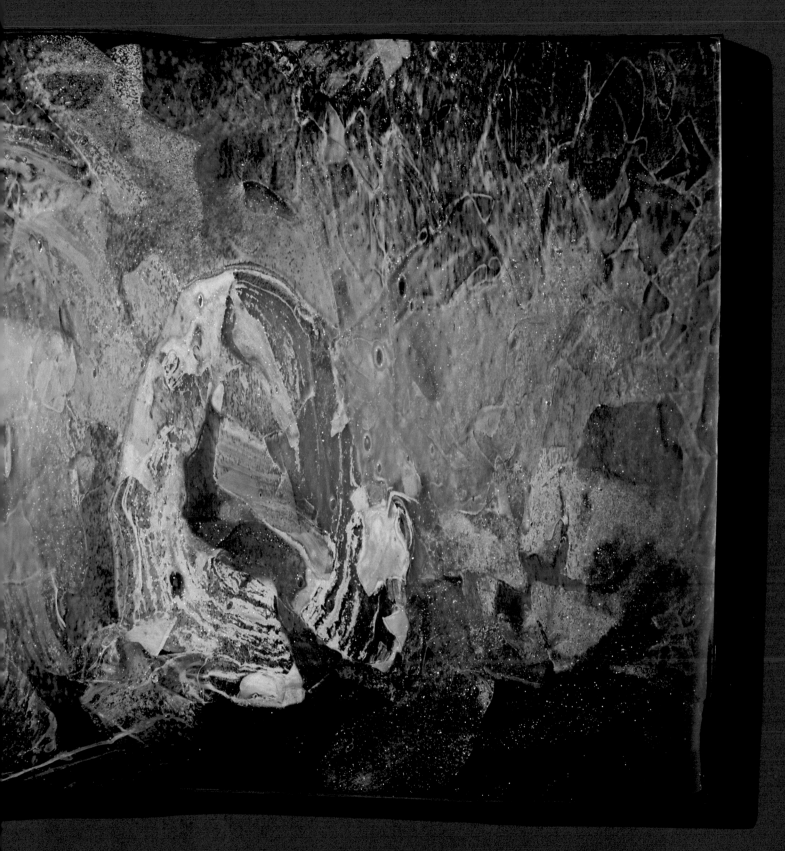

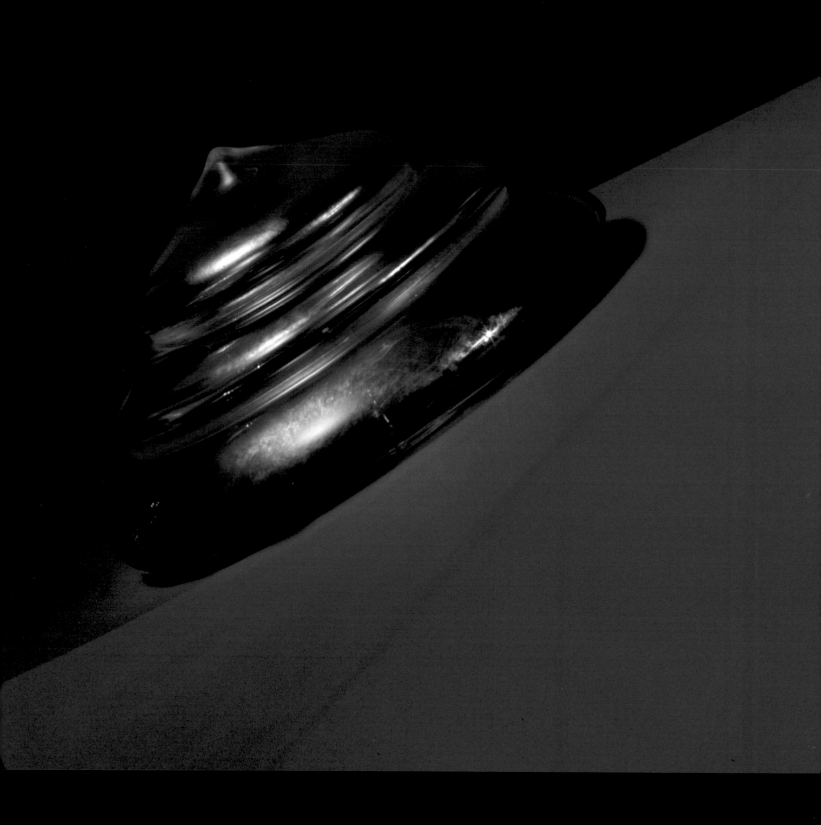

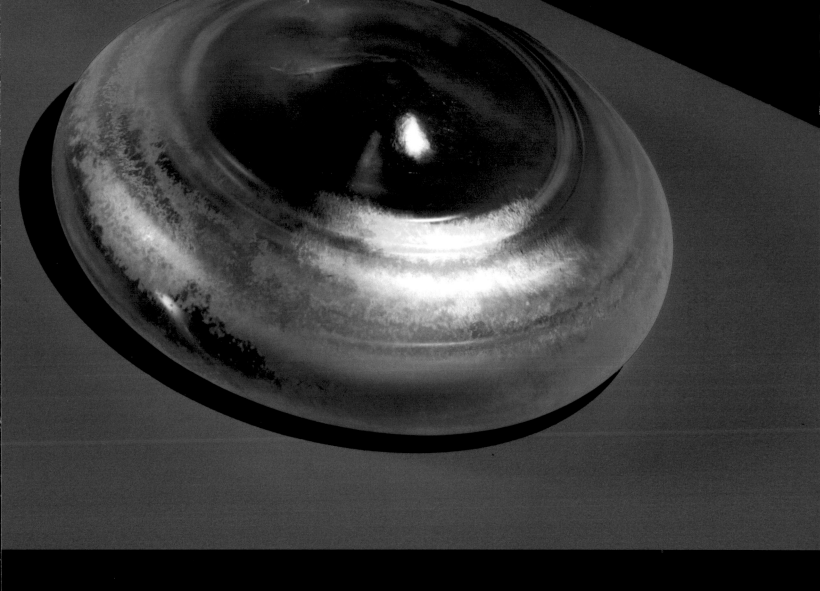

SHIFTS / FALSE MOVES

FRANCESCO DA RIN DE LORENZO

In these brief remarks, I will define a constellation, a paradigm of glass, through five movements represented by six personalities. I will focus on the manner in which production practices, leading from the artisanal art glass tradition in Murano to contemporary glass, have diverged and, in certain cases, been misunderstood.

This is by no means a rewriting of the millennial history of glass but rather a concise pursuit of a thread that begins with the establishment of Ditta Cappellin Venini in Murano in December 1921 and which, through brief remarks on Paolo Venini, Ludovico Diaz de Santillana, Dale Chihuly, and James Carpenter, and thus through the continuous and fertile relationship between Murano and the United States, brings us to the works of Alessandro Diaz de Santillana and Laura de Santillana.

PAOLO VENINI AND THE FIRST SHIFT: THE MODERN TRADITION

Current writing does not sufficiently emphasize how, at the age of only twenty-seven, Paolo Venini was a lawyer in Milan.

For centuries, the Venetian Republic considered the glassmaking tradition in Murano to be a state secret, subject to extremely rigid laws, including the death penalty, that prevented the release of information about processes for the production and manufacture of glass.

In 1295, by decree of the Venetian Republic, all glass furnaces in Venice were moved to the island of Murano for security reasons and in order to gain better control over production activity. Glass masters had to live on the island and could not leave without special permission. Only someone born on Murano was counted as a citizen of the island; moreover, glass masters were equivalent in status to nobles. In 1602, *Il libro d'oro* (The Golden Book) was created, which was simultaneously a census of Murano families and glass masters. It was very difficult to qualify for registration in the book, and those who were left out could not engage in any work related to glass production.

These restrictions did not end until the nineteenth century, with the French occupation of Venice, and they left a lasting influence on the mentality of the island's inhabitants. In 1921, these constraints were still very strong, making entry into the glass world of Murano an extremely risky undertaking for outsiders.

What emerges immediately from my reconstruction of events is the strategic quality of Paolo Venini's attitude and choices, from presenting himself as a Cappellin partner—thus Venetian to all intents and purposes—to concealing

his stylistic choices behind the firm's artistic directors, who, like Zecchin and Martinuzzi, were fully integrated into Murano life.

For the past thirty years, writing about Murano glass has focused on the objects that Venini produced, reducing the discourse to a mere question of attribution of signature: whether works are by Scarpa, Buzzi, Bianconi, or Martinuzzi, to mention the most famous names. Meanwhile, real events were unfolding elsewhere, namely, in the form of large orders for the lighting of public projects created under Fascism during that period.

These are somewhat complex issues, but to summarize, Paolo Venini, specifically because he was from Milan, where he had practiced law until the age of twenty-seven, brought to artisanal glass the entire debate about industrial production that was taking place in Europe. Approaches ranged from the German Werkbund's attempts to reconcile soul and technique, art and mass production, and Kultur and Zivilisation, to William Morris's Arts and Crafts movement, which saw an autonomous future for the craftsman within modern life, to a more precise understanding of the relationship between craft and industry as found in the writings of Adolf Loos, the great Viennese architect, and to the interpretation, in large part Italian, of international rationalism in merely stylistic terms.

Over time, Venini glassworks' production would become synonymous with the tradition of Murano blown glass. This is true for traditional objects but not for furnishings and large installations, which instead are purely innovative. At first, it was a question of standardizing production through the use of traditional techniques that lent themselves to the creation of works in quantity. With this adaptation, Venini was able to acquire contracts for many of the lighting fixtures for post office, railroad, and bank buildings that were being constructed in Italy during the 1930s. This, too, only hints at a complex situation involving the marketing strategies that allowed Paolo Venini to address that market. High-quality decorative objects stimulated the acquisition of public contracts, and the artistic directors of the firm were strategically involved in building relationships. Martinuzzi was the designer for the poet Gabriele D'Annunzio and worked directly with the architectural engineer Angiolo Mazzoni, director of the Ministry of Communications planning offices and the person responsible for postal and railway service infrastructures. Furthermore, Paolo Venini immediately set in place a sales network linked to directly owned, single-brand stores, beginning with one on the Via Montenapoleone in Milan.

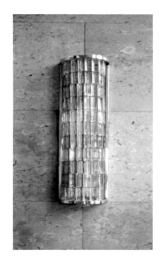

Venini & Co., wall sconce for the Gorizia post office

None of these glass objects had names but simply belonged to the Venini brand. During this period, special projects were also associated with Venini, such as the glass sculptures by Martinuzzi for the Milan Triennale and the Rome Quadriennale, including his *Piante Grasse* (Succulents), which is more than nine feet tall, and *Josephine Baker*, 1929, which exceeds six feet in height.[1]

But 1952 saw a true qualitative leap, with the glass ceiling for the Palazzo Grassi. For this, the glass sphere, a replicable multiple, allowed production through montage, resulting in an exceptional object: a glass pavilion forming the palace's interior courtyard.[2]

After the campaign of Fascist "modernization," Paolo Venini began looking for new clients, whose orders would allow him to stabilize mass production and begin to seriously approach the large market of the United States.

I would like to propose a precise moment when that relationship with the United States began to be defined: 1951, when Frank Lloyd Wright visited the Venini glassworks. Photographs of that visit show Wright, his wife Olgivanna, and the leading lights of Italian architecture at the time: Carlo Scarpa, probably the most important Italian architect of the postwar period, who had been art director of Venini from 1934 to 1948 and would be rector of the University of

Luigi Piccinato, series of wall sconces designed in 1930

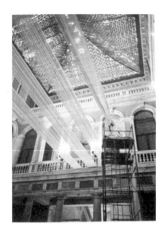

Paolo Venini, glass ceiling, Palazzo Grassi, 1952

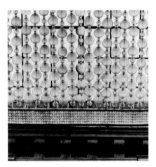

Paolo Venini, glass ceiling (detail), Palazzo Grassi, 1952

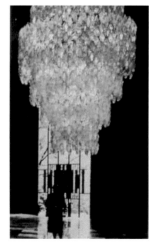

Paolo Venini, 1958 World's Fair, Brussels, Italian Pavilion with polyhedron chandeliers

Architecture in Venice from 1971 to 1974; architect Bruno Zevi, another important Italian figure, who had taken refuge in the United States after promulgation of the racial laws and who disseminated Wright's work in Italy; and architect Giuseppe Samona, rector of the Faculty of Architecture in Venice until the late 1960s. Other important figures in the Italian cultural panorama of the time also appear in the photos, along with the extremely young Anna Venini, Paolo's daughter, but the figure who takes center stage is, from our vantage point, more interesting—Oskar Stonarov, curator of the Frank Lloyd Wright exhibition in Florence and the former colleague of Louis Kahn, through whom he developed relationships with unions in Detroit, including the United Automobile Workers (UAW). A few years later, in 1957, Stonarov would propose that the UAW commission a large ornamental glass wall, to be created by Venini glassworks.

The next step in moving toward mass production was the 1958 invention of the polyhedrons, elements that could be easily assembled into enormous chandeliers that would have been impossible to make using traditional techniques.

Paolo Venini died on July 17, 1959; his son-in-law, architect Ludovico Diaz de Santillana, took his place as head of the glassworks.[3]

LUDOVICO DIAZ DE SANTILLANA AND THE SECOND SHIFT: SHARING AND EXCHANGE

Ludovico Diaz de Santillana would continue with the plans already set in place by Paolo Venini, developing them in a personal direction but without ever failing to observe the company's signature style.

He immediately had to organize and oversee the application of the polyhedrons in Carlo Scarpa's work for the Venetian Pavilion, created for the centenary of the unification of Italy, an event that was celebrated in Turin in 1961.

Ludovico Diaz de Santillana also symbolized another shift in terms of the connection to the Murano tradition: he was not Venetian and his genealogy was complex. He brought back a breath of fresh air, an international cosmopolitanism, to the provincial, local idiom that was typical of not only Murano but also Venice and Italy as a whole at that time.[4] His dual heritage was the product of two very different and strongly defined people; his mother, Anne Jonkman, was from a strictly observant Dutch Calvinist background, while his father, Giorgio Diaz de Santillana, was a scholar who left Italy in 1938 to teach philosophy and epistemology at the Massachusetts Institute of Technology (MIT) in Boston.

Giorgio Diaz de Santillana is too complex a figure to define here. He was a student of Federigo Enriquez, an Italian epistemologist and mathematician who struggled continuously with the idealism of Benedetto Croce and Giovanni Gentile, whose pernicious ideologies still affect Italian attitudes and education. Santillana was one of the most important experts on Galileo and also proposed an interesting reinterpretation of classical thought in *Il mulino di Amleto: Saggio sul mito e sulla struttura del tempo* (Hamlet's mill: An essay on myth and the frame of time), published in 1969, which he coauthored with Hertha von Dechend. The themes and fiction of Italo Calvino, one of the best-known Italian writers in the United States, show his influence, from *Cosmicomics* to *Six Memos for the Next Millennium*, a series of lectures presented at Harvard University in 1985–86.

Giorgio Diaz de Santillana married his second wife, the former spouse of Pulitzer Prize winner Robert Hillyer, in the United States. Further complicating this relationship, Laura Venini, Paolo Venini's other daughter, married Robert Hillyer's son, Stanley, and moved to the United States, where she still lives. Thus the Santillana and Venini families are twice related.

This history, which might seem marginal in terms of the themes addressed here, is precisely why Ludovico Diaz de Santillana agreed to have American artists such as Dale Chihuly come to the glassworks and learn to blow and work glass, making Venini the only Murano establishment to do so.

Carlo Scarpa's *caminetto* showed Ludovico Diaz de Santillana new possibilities for the assembly of replicable multiples. Thus, new modular systems soon emerged, with elements that could be aggregated and put together, such as rods, reeds, tubes, panels, modules, and drops.

Venini & Co., Murano, 1951

The next selection of photos is meant to illustrate how much of Venini's production, under the guidance and, particularly, the art direction of Ludovico Diaz de Santillana, has been concerned more with large furnishing elements than with the individual object and how the assembly of replicable elements has resulted in constellations that avoid geometric configuration, rigidity, and symmetry. We now know that this type of production foreshadowed the Venini object's shift into the art field, but at the time, Ludovico Diaz de Santillana, as an architect, looked at these objects only as a slight variation on the practical glass object and thus saw himself as the developer of a good artisanal product. Indeed, while much of the Venini production from 1959 to 1986 was the result of Ludovico Diaz de Santillana's inventiveness and creativity, nothing bore his signature.

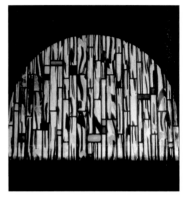

Oscar Stonorov (designer); window for the United Automobile Workers main conference hall (Detroit), 1957

Here, it is worth mentioning another little-known story related to the World Trade Center. The American public may not know that the Doge's Palace in Venice was an overt reference point for the towers' designer, Minoru Yamasaki. The bases of the towers display the structural outline of the Venice landmark, with a closed, monolithic body superimposed on a delicate lacework design. Yamasaki continued the Venetian reference by having Ludovico Diaz de Santillana design and create all the lighting for the plaza and lobbies.

This project, along with many others, brought international recognition to the relationships that Ludovico Diaz de Santillana had succeeded in weaving over time, thanks to his character and his international education. These relationships, moreover, often involved the entire island of Murano when projects exceeded Venini's production capacities.

DALE CHIHULY AND THE THIRD SHIFT: THE RUPTURE OF CAUSAL RELATIONSHIPS

I have only hinted at the shift from series of practical objects—the system of "implements" connected to one another according to a cause-and-effect logic, that Platonic sequence in which things are joined together *as in a discourse*, with the intent of serving a useful purpose—to a series of objects that, at least apparently, have no purpose and which in the final analysis can be seen as art, according to the Aristotelian opposition to Platonic theses. This superimposition is consistently strong within material traditions, from ceramics to glass, and results in knots that are difficult to undo, as art always seems to fall back within the modalities of craft.

The Murano glass master is surely a craftsman, perhaps even an excellent craftsman. His goal, working freehand and without the aid of technology, is to perfectly replicate an object that is always, or almost always, an object of use. This "pact of parity" between art and craft defines both the beauty of the object and the skill of the master, which attain the level of true virtuosity.

In 1968, when Dale Chihuly began blowing glass at the Venini furnaces—he was definitely the first American, and perhaps the first foreigner, to blow glass in Murano—the masters clearly did not view him as competition. Without

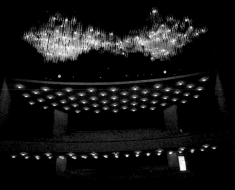

Venini & Co., Schweinfurt Theater drop system, Germany, 1967

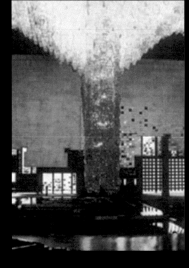

Dis. Carlo Scarpa (designer), *The Caminentto* (Fireplace), using polyhedrons, for the Expo in Turin, 1961

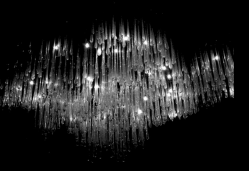

Venini & Co., Schweinfurt Theater drop system (detail), Germany, 1967

Ludovico Diaz de Santillana (designer) per Venini & Co., lighting elements for lobby interior, World Trade Center, New York

Ludovico Diaz de Santillana (designer) per Venini & Co., lighting pylon with reedlike lighting for World Trade Center, New York; Element is visible to the right of the sphere by Fritz Koenig

Venini & Co., Banco del Santo Spirito, Rome

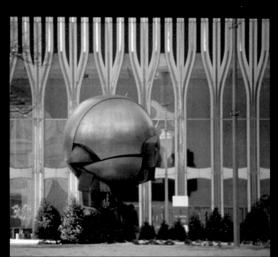

going into these complex environments, which I have analyzed at length elsewhere, I will limit myself to defining how that gesture conclusively broke the pact of parity that had evolved over the centuries.

Chihuly's chandeliers, which clearly owe something to Ludovico de Santillana's installations, are not lighting fixtures but, always illuminated from without, are meant to simulate frozen masses of light. At this point, it would be best to discuss the images attached to this text: the nonrepresentational "medusas" for the Banco di Santo Spirito (I do not know their date of execution), which might symbolize the exchange between Chihuly and Venini, although the first "nonrepresentational" product, created with an *a mano volante* technique, is the *Fazzoletto* (Handkerchief Vase) by Paolo Venini and Fulvio Bianconi, created in 1949; all the assembly systems for the large installations, such as Scarpa's 1961 *caminetto*; and the large glass wall created in Detroit in 1957.[5]

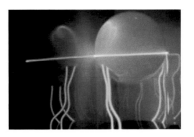

Dale Chihuly, *Venini Model*, 1968; Glass, plastic, neon

The strongest hypothesis is the one that links the installation *100,000 Pounds of Ice and Neon*, created by Chihuly along with James Carpenter in 1971 and reproposed in Tacoma in 1993, to James Turrell's and Dan Flavin's poetics on light and to works by Walter De Maria and Robert Smithson (such as *Leaning Mirror*, 1969, and *Mirror and Shelly Sand*, 1970), in the context of Land Art.

The other question that can be raised concerns the object, which in blown glass always tended to result in a known configuration—a glass, a plate, a vase—but in Chihuly's work is never the outcome. The process is interrupted at a point that I would define as "unconsciously" planned, which gives rise to a series of stills of that very process. Thus we are dealing with the rupture of the work's relationship with the reference model, an interruption of the connection to the prototype.

In this case, the strongest reference within American artistic poetics is the connection to Mark Tobey's Pacific School. In Tobey's thought, the object is the result of a lightning-swift movement, united with a velocity of execution that he would relate to the Zen concept of *ko tzu* (spontaneity), according to which inspiration must move from the body to the object in the least time possible, without reflection, erasure, or second thoughts.

JAMES CARPENTER AND THE FOURTH SHIFT: THE UTOPIA OF CONSTRUCTIVISM

James Carpenter accompanied Dale Chihuly to Murano in 1972, as both his student and a partner in an artistic association that would last for some years. This was the beginning. Later, their paths would diverge completely.

In 1972, Carpenter produced the *Calabash* and *Tessuti* (Textiles) series for Venini, the former clearly evocative of the woven baskets of Native Americans, to which the name refers. Carpenter then brought in Ludovico de Santillana to perfect the assembly of the flat glass walls, the same panels that Paolo Venini had assembled in *New Cathedral of the 20th Century* for the United Auto Workers in Detroit.

In this collaboration, I see an extreme change in course and objectives. While, in 1972–74, Carpenter was concerned with the ideation of more traditional products, such as vases, in 1982, he collaborated with the architect Norman Foster on the design for a new type of translucent *brise-soleil*, which he integrated into the sheets of glass in the facade for the Hong Kong and Shanghai Bank. In contrast, Paolo Venini had already thoroughly understood and methodically pursued this shift, embarking on a change in direction he intended to implement across the entire production sector of

artisan glass. And as early as the 1970s, Ludovico de Santillana attempted to bring the artisan qualities of Venini design to industrial glass production on the mainland.

Within this further shift, one can identify the persistence of the seeds of the Constructivist utopia, in which there is the possibility of dialogue between technique and art, which arrives at the transformation of technique as a function of art.

More specifically, this mixture is realized in architecture as ἀρχη (*árche*) and τέκτων (*técton*), that is, technique as a function of origins, of beginnings, of man himself, but also the management of the "void" that architecture represents. This is an enigmatic circularity that links the vase, as a void to be filled, to man, and man to the void that he inhabits.

And so it is no accident that Carpenter has been concerned predominantly with glass as it applies to architecture and that his current work on the facade of the new World Trade Center, while entirely different in themes and objectives, seems to me to be a long-distance conversation with Ludovico de Santillana.

ALESSANDRO DIAZ DE SANTILLANA AND LAURA DE SANTILLANA AND THE RETURN: THE DEFINITION OF THE ARCHETYPE—IN TERMS OF VASES AND MIRRORS

The long prologue I have presented defines a field of energy, four conceptual poles, schematically described and useful for communicating how the world and the production of artistic truth has been subjected over time to multiple forces and mutations.

Blown glass, which began as a high-quality artisan tradition, has in certain moments tended toward serial reproduction based on an industrial model, as in the case of multiples that can be replicated; in other instances, it has aimed to attain the status of art object.

Moreover, this tradition, which is still extremely structured in its geographic location, has often been modified through the intervention of an outsider, someone "foreign," as Paolo Venini could have been considered in 1921. And, like other outside contacts and contributions, including the influence of art produced by Dale Chihuly, another foreigner in Murano, these influences have decisively changed the goals and the very strategy of the product.

It must be equally clear that these modifications of tradition, these metamorphoses, have saved the tradition of blown glass, revitalizing it during periods of crisis. Laura de Santillana and Alessandro Diaz de Santillana, the children of Ludovico Diaz de Santillana and Anna Venini, fully and directly experienced these shifts.

Their works, in a wholly distinct and extremely personal fashion, are located within this electrical field. Initially, as designers for Venini, they created objects that still pertained to the field of artistic handicraft but, in certain cases, looked carefully to industrial design; then, almost simultaneously, they made a definitive leap toward the artistic experience, still conveying the entire experience and millennial knowledge of the Murano tradition.

The question, then, is to verify if, in Laura de Santillana and Alessandro Diaz de Santillana's absolutely modern work, one can still trace the thread that made it possible to link the past with the present, without rupture. For this has been Venini's most specific signature, something passed down from Paolo Venini to Carlo Scarpa, his onetime collaborator and the great architect of renewal, and then transmitted to Ludovico de Santillana.

Venini products seemed to possess a "strange" syntony in relation to both tradition and modernity: "Venini demonstrates the contradiction between the modern and tradition, indeed the perfect integration between historical culture

Laura de Santillana, *Varaha*, 2007

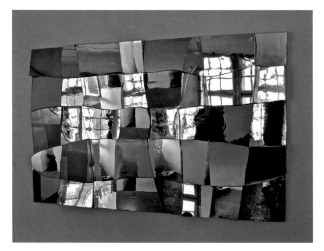

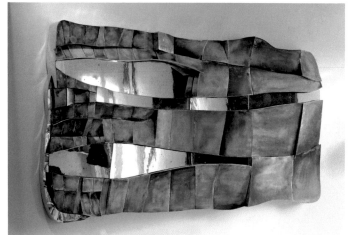

and tradition, on the one hand, and taste, ways of life and living, sensibilities, and contemporary languages, on the other … without dreams of impossible and futile reversals."[6]

Both Scarpa's works and the furnishings personally designed by Ludovico de Santillana, objects of quality, coming from different systems and eras, perfectly communicate, fully express, how that possibility of "happy" coexistence is not inherent to the specific characteristics of glass, but rather is *a way of life and of living* on the earth.[7]

It requires no great interpretive effort on my part to see in Laura de Santillana's works the multiplication of the theme of the vase and in Alessandro Diaz de Santillana's, a constant relationship to the mirror.

The images presented here, which are deliberately different from the objects in the exhibition, should be sufficient to explicate my arguments. These images, together with the material nature of the objects on display, which each visitor will be able to investigate directly, declare—perhaps without there being any need to do so—that the terms "vase" and "mirror" define two concepts that appear to have an inexhaustible wealth of possibilities for their configuration.

These, then, are special vases and mirrors.

The theme of the vase and the mirror is not new, but what interests us here is defining how these material objects can mimic the enigma of the archetype.

The archetype has the power to indissolubly unite past and future, without fractures, without rifts, and so those objects must be considered simultaneously as objects of use and as signifiers.[8]

But let us proceed in orderly fashion: The two terms, "vase" and "mirror," recur throughout Lacan's oeuvre. They are special objects, material metaphors that alone can symbolize the absence/presence that the Lacanian "thing" represents.

The shift of Lacan's concept to an aesthetic context and, consequently, its transformation into a material object are applicable only to the extent that the object configures the management of the void, of the absence. That is a property that only language seems to possess.

I will leave this question open. After all, Lacan himself employed 24 seminars as well as various publications in his attempt to explain how the Thing is, in fact, something unutterable, indefinable in that it is pure absence, divarication, void, gap, which a few metaphors—such as, specifically, the vase and the mirror—can help to explain.

Above left: Alessandro Diaz de Santillana, *Untitled (Mudac)*, 2011

Above right: Alessandro Diaz de Santillana, *M1*, 2005

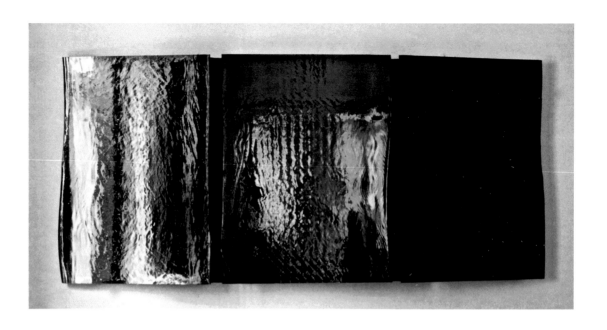

Alessandro Diaz de Santillana, *Trittico Arancio*, 2000

Lacan refers explicitly to an extra-psychoanalytic precedent, a text by Heidegger on *das Ding* (the Thing),[9] in which the scope is more specifically ontological and there is a return of the theme of the vase, of the jug, as a symbolic object suitable for uniting heaven and earth, human and divine, in which one "mirrors" the other in the "simplicity" of the framing that they both define.

The vase, which at the beginning of the essay seems to be a "thing" like any other, then is resolved etymologically (the original significance of the word) as the *coming together* that an ancient German word defines as "thing," and as the play of mirrors defined in the *framing* of the world.

Within the brief course of a lecture, Heidegger traces the outlines of that enormous void that Lacan, from another viewpoint, then attempts to fill; this is a system of recursiveness,[10] one of those cases in which a play of words can reproduce the subject of the arguments, in which dealing with vases as voids configures a void.[11]

And so the object—whose significant traces, which Lacan addresses, are fully configured as material (*the fact remains that these signifiers are forged by man, and probably even more with his hands than with his mind*), having lost the known configuration of an implement—is defined as a force field that is simultaneously opposed to interpretation but incessantly requires it.

The object loses its function, which is tied to use, to be transformed into an inexhaustible chain of "signifieds" (ideas expressed by signs); it is transformed into "sign" and goes beyond the immediacy of its use, and thus the vase ceases to be a mere receptacle.

The work of art appears inexhaustible, even historically inexhaustible, precisely because it is a signifier; the art object, frozen for eternity in its unmodifiable material nature, in its structure, is continuously plowed and modified by a thousand meanings. It cannot be immediately consumed through the practice of recognition.[12]

This next step, then, is the practice of interpretation, of the exegesis of the object transformed into text. And so, whatever relationship is established between linguistic paradigm and extralinguistic series, it is always on the brink *of a reciprocal attraction*, suspended between the futility of the "translator," with regard to the immediate clarity of things—the myth of the self-referentiality of the work, the unquestionable perception that every work, like every text, cannot help but

autonomously communicate everything that it must and can communicate—and the enigmatic opacity of things, illuminated by the presumed clarity and accessibility of language.

This discourse would seem to prefigure a sort of gnoseological premise, while it is absolutely critical to understand the works we are discussing: the vase and the mirror.

Returning to Lacan's reasons for speaking of vases and mirrors, an answer can be found in the hypothesis that the vase is the first object created by man, while the mirror symbolizes the relationship between sign and reality. This prefigures the possibility that something as immaterial as a reflection might represent material reality and so, within the myth of Narcissus, might define the trigger for the symbolic device, the birth of language, the structuring of man as a semiosic animal.

Moreover, if the mirror requires our physical presence in order to reflect our image, any system of signs acts only in our presence; you must be bent over the open book, as above a mirror, in order for it to signify. Similarly, it is through the presence of our minds that material reality acquires significance, and without that, everything would be mute. In other words, one might say that every work hides within itself a mirror in which we are being reflected.

Thus, for Lacan, it is the first ever object that must be sought, because it profoundly and symbolically represents us. In other words, the lost object cannot be a mere thing (*la chose*, in French, from the Latin *causa*) that is linked to the infinite network of causal connections but must be able to represent man himself as the first cause, the first impulse to that process, with, again, man as the ultimate conclusion of that process: no longer the means of action, but its end.

After all, the object, in order to be able to reveal the possible compresence of means and end, must be able to free itself definitively from the chains of belonging; it must be forced to break away, however, while maintaining an indelible memory of them. It must disconnect from the system of needs to which its use refers and, at the same time, remember it, possess a recollection of it. This is very closely connected to the phenomenon of estrangement, which the Russian formalists also dealt with at the linguistic level[13] but Duchamp used extremely effectively in an art context.

And to do this, to be able to aspire to being "the Thing" to which Lacan refers, the object must renounce utility. As an end, its total gratuitousness, its futility, must be obvious. And every futility refers to the luxurious and to the frivolous, which are the categories through which man uses the world.[14]

Futile but unquestionably necessary.

In order to reveal the compression of means and end in the same place, I must then force that object to separate itself from the chains of belonging; I must make it devoid of any function so that its disconnection emerges from the system of necessities. I must remove the vase from the chain of useful vases, the mirror from the chain of functional mirrors, and I must be able to go back to seeing the vase and the mirror through a process of estrangement from the series. I must be able to see them as if for the first time.

And so, in this sense, the object must be presented as a rediscovered object, rediscovered in that it is sought. And in this way, we must also succeed in imagining the amazed glance of the author facing his own work, which never completely belongs to him if it is to truly be itself.

And so the object can appear lost precisely because it appears rediscovered.

Thus only a posteriori.

Alessandro Diaz de Santillana presents us with a montage of shattered mirrors, or the distortion of the image in imperfect reflections.

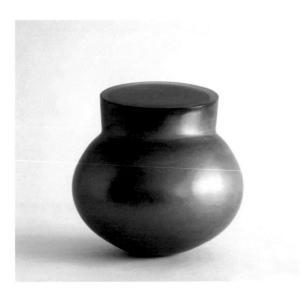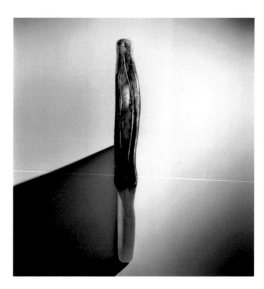

In this case, too, the relationship between the referent and its trace is problematic. The reflection never perfectly defines a figure; on the contrary, it presents its fracturing, the imperfection that exists between the two levels, the impossibility that reality might find a home within the incorporeal reciprocity that language represents.

If the source language is a way of preserving the absence of things and facts, a way of *managing* in the invisible, and thus in their absence, being able to define in any case what has happened within the actions of a process, then in its shattering, it is the singularity of the different viewpoints, the decomposition and impossibility of reconstructing a single figure, that prevails. It definitively declares the opacity of language that has occurred, the crisis of that pact within language that men have made with one another.

For some time, Laura de Santillana has produced closed, hermetic vases into which she inserts or above which she draws signs, enigmatic writings, and textures.

As I have already noted, the man who is born shaped from clay, thus made of earth, is a vase. The vase that Pandora opens is man and his history. And so, does keeping vases sealed, in addition to eliminating any possibility of their use, also signify something?

Even the shift from the material nature of earth to the transparency of glass presents other questions, for glass is blown, and breath mimics the possession of the pneuma, of life, and also the emission of the word. It immediately brings to mind the Hebraic myth of a god who creates, naming, or the vision of an angel with swollen cheeks playing a trumpet. These considerations seem to pertain to the realm of the arbitrary, but one need only put oneself in the place of the man completely enveloped by the magic of the symbolic to experience the thrill of seeing glass arise from sand, from dust. It is as if the earth to which we return contained the secret of a crystalline eternity, as if the obscure opacity of the material could reveal the magical transparency of the invisible. Cinerary urns, terra-cotta containers, always enclose, mixed with ashes, a series of objects that time cannot erode: jewels, golden necklaces, glasses or glass cruets. And so the circle is closed: vase/man returns to earth, reduced to ashes, while the irreducible glass reveals the flash of intuition or the illusion of the magical presence of an incorruptible soul within the clay.

Perhaps I would not be able to say all this if I did not know how critically important the realms of writing and reading are to the lives of Laura de Santillana and Alessandro Diaz de Santillana. Through these practices, the family's participation in the domain of culture has been further defined, as the immense pile of books, the long rows of shelves in the family library, have been transformed into a library of glass pieces, signifying a further synthesis between words and things that might be possible only in these ways.

We also need to know how their grandfather, Giorgio Diaz de Santillana, fully participated and assiduously worked within that environment. I do not know the extent of the influence of the archaic cosmogonies of their grandfather, whose beginnings lie within the eternally churning maelstrom,[15] for in the end, the vase is nothing but a frozen vortex.

Certainly the dream of the grandfather, which was again a relationship between macrocosm and microcosm, according to the episteme of similarity outlined by Cusano, has been fractured. If, as Freud says, we are grounded in our sexuality, where in those cosmogonies is the sexual organ of the universe located? And if language, the vase, the mirror, simultaneously give rise to the Law, to patricide, to the prohibition against incest, how is it possible to reproduce the Loop, the idea that thinks of itself thinking, without sexuality?

Is this, then, the true significance of the shattered mirror, of the vase/book? Is it the perception of the fracture within the episteme of similarity to which, to all intents and purposes, language also pertains?

But if science finds it difficult to reconcile cosmogonies and sexuality, in art, sexuality is always immediately perceptible, and sometimes cosmogonies as well.

ENDNOTES

1. See images and text for both in Anna Venini Diaz de Santillana, *Venini Catalogo Ragionato, 1921–1986* (Milan: Skira, 2000).

2. The glass ceiling, nearly 2,400 square feet in area, was taken down in the 1980s during the restoration of the palace under the supervision of architect Gae Aulenti. It was preserved in 56 large crates, where it remains to this day. During a subsequent restoration, the Japanese architect Tadao Ando, working for the Pinault Foundation, current owner of the palace, assessed the possibility of reassembling the ceiling but decided against doing so because it diverged from his stylistic objectives.

3. At the time of Paolo Venini's death, Ludovico Diaz de Santillana was in Paris, overseeing some projects before leaving for the United States, where he had been appointed a professor at the Massachusetts Institute of Technology. He was detained in Paris because his wife, Anna Venini, was about to give birth to their second child, Alessandro, who was born on July 18.

4. I say "brought back" because sixteenth-century Venice was a model of the contemporary metropolis, as Nietzsche had written earlier: "A hundred profound solitudes together form the city of Venice—that is her magic. An image for the men of the future." As such, it anticipated New York, a true place of exchange and growth. I admit that the words, taken out of context, can leave the reader perplexed, and yet the local idioms belong to that idea of community from which the foreigner, the stranger—the unknown person who, for the Greeks, always presented a possible encounter with a hidden god—is excluded. Paradoxically, the "foreigner," Ludovico Diaz de Santillana, closely followed the customs of the original Venetian, a citizen of the world.

5. Here, I am discussing it from a "technical" viewpoint, but from a "poetic" viewpoint, I would like to point out the presence of skies and constellations in the images.

6. "Rampante Venezia della modernità," in *Venini Murano 1921*, FMR catalogue, 35.

7. In Ludovico de Santillana's furnishings, it seems that nothing can be eliminated and everything can be integrated, ancient and modern, as well as different cultures.

8. By "signifier" I mean, according to the definition of Ferdinand de Saussure, which was then reasserted by Roland Barthes, the material conveyor of meaning. Signifier and signified thus represent the inseparable structuring of the sign.

9. Martin Heidegger, *Das Ding*, translation by Albert Hofstadter, in *Poetry, Language, Thought* (New York: Harper and Row, 1971).

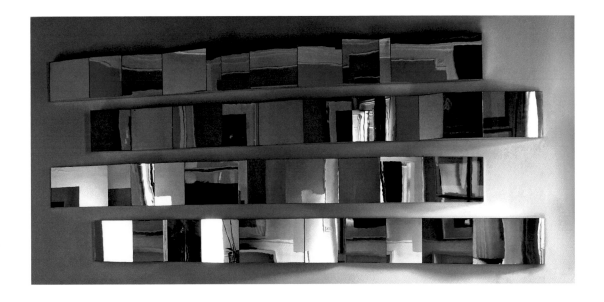

10. "Recursiveness" and "isomorphisms" are the two terms around which Douglas R. Hofstadter's text *Gödel Escher, Bach: An Eternal Golden Braid* (New York: Basic Books, 1979) is structured.

11. I shall stop here and refer the reader to those pages, which are apparently infinite in their complexity.

12. The question becomes more complex if one considers Aby Warburg's studies on antithetical expressions. Examining reproposals or Renaissance quotations of classical images, Warburg realized that the same expressions of the face, the same compositions or postures of the body, had a changed significance over time; see Kurt W. Forster, *Introduzione a Aby Warburg e all'Atlante della memoria* (Milan: Bruno Mondadori, 2002).

13. Viktor Šklovskij, *O teorii prozy* (Moscow, 1925), ostranenie (**отстранение**).

14. The archaic logics of need as opposed to desire were shattered by Freud and then recomposed in impulses, where they are recompressed, to further proliferate. The literature is quite rich and complex, from Lacan himself, to Derrida, to Bataille, to Baudrillard, whom I mention because they are cited by Francesco Dal Co in his essay on Carlo Scarpa, "Genie ist Fleiss: L'architettura di Carlo Scarpa," in *Carlo Scarpa: Opera completa* (Milan: Electa, 1984).

15. See the aforementioned *Il mulino di Amleto: Saggio sul mito e sulla struttura del tempo* (1969), by Giorgio de Santillana and Hertha von Dechend.

Alessandro Diaz de Santillana, *Untitled (ER2)*, 2007

ARTISTS' INSPIRATIONS

 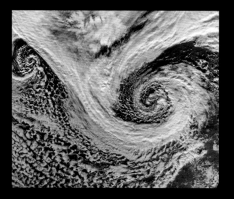 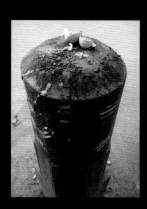

LEFT TO RIGHT: Soulier and J Andriveau-Goujon, *Atlas Elementaire Simplifie De Geographie Ancienne Et Moderne*, 1838; votive stupa, Bodhgaya, 11th–12th century (1001–1200); NASA Earth Observatory, *Satellite Photograph of extratropical cyclones Near Iceland*, November 20, 2006; lingam at Thousand-Pillared Temple, Warangal, Andhra Pradesh, India, 2003; Chandra X-ray Observatory and Hubble Space Telescope composite image of *Cat's Eye Nebula Redux*; Jackson Pollack, *One* (Number 31, 1950), 1950; European Space Agency/German Aerospace Center/Freie University Berlin, Color Enhanced Telescope image of residual water ice on the floor of the Vastitas Borealis Crater, Mars, February 2, 2005

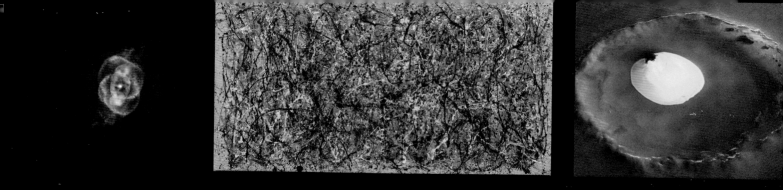

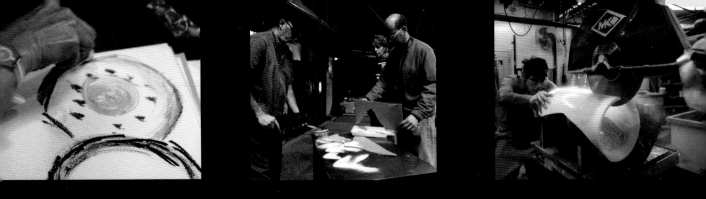

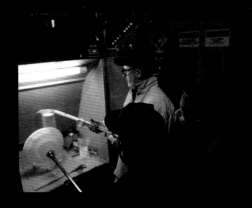

BIOGRAPHIES

ALESSANDRO DIAZ DE SANTILLANA is a third-generation glassmaker who honors the tradition of his father and grandfather while establishing his own successful career in glass. He was born in Paris, studied at the University of Venice, and joined the family firm, Venini, in 1981. At the same time, he began exhibiting his own work in dozens of solo and group shows around the world, including in Italy, France, the United States, Singapore, Switzerland, Austria, England, The Netherlands, and Germany. His work also is included in public and private collections worldwide. In recent years, he has completed commissioned artworks in Australia, Singapore, England, France, and the United States. Recently, he has collaborated with his sister, Laura de Santillana.

LAURA DE SANTILLANA, an internationally recognized artist and designer, continues the Venini family glassmaking tradition. She was born in Venice, Italy, and studied at School of Visual Arts in New York City. Her work first appeared in the United States in 1979 as part of the traveling exhibition *New Glass: A Worldwide Survey*, organized by The Corning Museum of Glass. Since then, she has had solo exhibitions throughout the United States, Switzerland, France, Italy, Belgium, Austria, and Japan and has participated in group exhibitions in Europe, North America, and Asia. Her work is on display in prestigious museums in the United States (Pittsburgh, New York, Los Angeles, San Diego, Denver, Houston, Saint Louis, and Seattle), Europe (Munich, Düsseldorf, Coburg, Paris, Lausanne, Venice, Hamburg, London), and South America (Brazil). Recently, she has been creating new work with her brother, Alessandro Diaz de Santillana.

DR. BALKRISHNA DOSHI, a Fellow of the Royal Institute of British Architects and of the Indian Institute of Architects, has long been active in arts, architecture, and design.

A native of Pune, India, he studied at Sir J.J. School of Architecture, Mumbai, and worked in Paris and India, particularly in Ahmedabad in the Indian state of Gujarat. He established the environmental design firm Vastu-Shilpa in 1955. Dr. Doshi has been a member of the jury for several international and national architecture competitions, including the Pritzker Prize, the Indira Gandhi National Centre for the Arts, and the Aga Khan Award for Architecture.

Dr. Doshi is equally known as an educator and institution builder. He has held educational leadership positions in architecture, planning, environmental planning and technology, and visual art. Dr. Doshi is the founding director

of the internationally known research institute, Vastu-Shilpa Foundation for Studies and Research in Environmental Design, which has done pioneering work in low-cost housing and city planning.

Dr. Doshi has received several awards and honors, including Padma Shri, presented by the government of India to recognize distinguished contributions in various spheres of activity, and an honorary doctorate from the University of Pennsylvania.

FRANCESCO DA RIN DE LORENZO was born in Cortina d'Ampezzo in 1958. He studied under Manfredo Tafuri, Massimo Cacciari, and Aldo Rossi at the University of Architecture in Venice between 1977 and 1982 and opened his own office in 1983. Over a long career, Da Rin has restored important buildings in the UNESCO natural heritage area of the Dolomites and contributed innovative techniques to new construction. In 2001 he was appointed to the Committee of Communication, Information and Culture for the Federation of Veneto Boards of Architecture in northeastern Italy. In 2002 he began working with Emilia Perego, and in 2008 they founded Da Rin Perego Architetti associati. In 2007 their firm started working in South Korea, where they won first prize as best international presence for the project and curatorship of the Veneto pavilion at the Incheon Global Fair and Festival in 2009.

In 1976 Da Rin De Lorenzo met the de Santillana and Venini families. In 1999 he collaborated with Anna Venini on a book about the large glass lighting installations produced by the Venini family. This project led to intense research on the relationship between Murano glass and American artists such as Dale Chihuly and James Carpenter. Da Rin De Lorenzo collaborated with Alessandro Diaz de Santillana on a monumental glass sculpture for the Novena Center in Singapore. In 2005 he designed a glass city for the Venice Architecture Biennale, and his Murano Glass exhibition for the 2007 Cheongju Craft Biennale in South Korea won first prize. Da Rin De Lorenzo was also a professional ice hockey player for 20 years.

DR. DAVID LANDAU is a medical doctor and art historian. He cofounded *Loot*, a free-advertising periodical, in 1985 and was its joint managing director and chairman until the company was sold in 2000. He then founded Saffron Hill Ventures, a venture capital company specializing in early-stage and clean technologies. He is the founder and former editor of *Print Quarterly*, a scholarly journal devoted to the history of printmaking, and has published several books in art history. He served as a trustee of the National Gallery of Art between 1996 and 2003 and is currently on the board of the National Gallery Trust. Dr. Landau is a founding member of the Board of Governors of the Courtauld Institute of Art and a former member of the Committee of the Art Fund. He was chairman of the Finance and Investments Committees and Curator of Pictures for Worcester College, Oxford, of which he was also a fellow. In 2010 he was Chairman of Foundazione dei Musei Civici di Venezia.

CHECKLIST

April 2012 – January 2013
Organized by Museum of Glass
North Gallery

Dimensions are height precedes width precedes depth.
All objects were made by Laura de Santillana (Italian, born 1955)
or Alessandro Diaz de Santillana (Italian, born 1959);
all objects are courtesy of the artists.

All objects were made at Museum of Glass, Tacoma, WA,
in February and October 2010.

LAURA DE SANTILLANA

MERU (*Black*) (page 45, right)
Blown glass
23 ¹/₂ x 12 ³/₄ in. (59.7 x 32.4 cm)

MERU (*Amber Steps*) (page 49)
Blown glass
30 ¹/₂ x 11 in. (77.5 x 27.9 cm)

MERU (*White*) (page 50)
Blown glass
25 x 14 ³/₄ in. (63.5 x 37.5 cm)

MERU (*Two Peaks*) (page 44)
Blown glass
22 ³/₈ x 16 ¹/₄ in. (56.8 x 41.3 cm)

MERU (*Clouds*) (page 55)
Blown glass
25 x 14 ¹/₂ in. (63.5 x 36.8 cm)

MERU (*Blue*) (page 45, left)
Blown glass
20 ¹/₂ x 19 ¹/₂ in. (52.1 x 49.5 cm)

Space 0 (page 41)
Blown glass, gold gild
8 x 4 in. (20.3 x 10.2 cm)

Space A1 (page 26, left)
Blown glass
15 x 10 ¹/₂ in. (38.1 x 26.7 cm)

Space A2 (page 26, right)
Blown glass
13 ¹/₂ x 10 ¹/₂ x 9 ¹/₄ in. (34.3 x 26.7 x 23.5 cm)

Space A3 (page 27, left; detail page 23)
Blown glass
14 ³/₄ x 10 ¹/₂ in. (37.5 x 26.7 cm)

Space A4 (page 27, right)
Blown and sculpted glass
5 ⁵/₁₆ x 4 ³/₄ x 13 ³/₄ in. (13.5 x 12 x 35 cm)

Space B1 (page 32c, left)
Blown and mirrored glass
16 ⁹/₁₆ x 10 ¹³/₁₆ in. (42 x 27.5 cm)

Space B2 (page 32c, right)
Blown glass, silver leaf
6 ³/₄ x 14 x 9 ³/₄ in. (17.1 x 35.6 x 24.8 cm)

Space B3 (page 32d)
Blown glass
15 ¹/₄ x 10 ¹/₂ in. (38.7 x 26.7 cm)

Space B4 (page 33)
Blown glass, silver gild
5 x 5 ¹/₄ x 4 ³/₄ in. (14 x 14.5 x 12.1 cm)

Space C1 (page 32, left)
Blown glass
13 ¹/₂ x 9 in. (34.3 x 22.9 cm)

Space C2 (page 32, right)
Blown glass
14 ¹/₂ x 14 x 8 ¹/₂ in. (36.8 x 35.6 x 21.6 cm)

Space C3 (page 32a)
Blown glass
6 ³/₄ x 23 ¹/₄ x 6 ³/₄ in. (17.1 x 59.1 x 17.1 cm)

Space C4 (page 32b)
Blown and sculpted glass,
silver and gold gild
5 ¹/₂ x 7 ⁷/₈ x 16 ⁵/₁₆ in. (14 x 20 x 41.5 cm)

Star (*Blue*) (page 95)
Blown glass, silver, copper, and gold leaf
4 x 18 ¹/₂ in. (10.2 x 47 cm)

Star (*Blue*) (page 94)
Blown glass, silver and gold leaf
3 ³/₄ x 19 ¹/₂ in. (9.5 x 49.5 cm)

Star (*White Green*) (page 83)
Blown glass, gold leaf
4 ³/₄ x 17 in. (12.1 x 43.2 cm)

PHOTO CREDITS

All photos by Russell Johnson and Jeff Curtis unless otherwise noted.

Credits are listed by page number and in page order. When there are multiple credits on a page, they are listed from top left.

2–4: Photos by Russell Johnson

15: Photo by Russell Johnson

20: Dis. Napoleone Martinuzzi (Italian, 1892–1977) per Venini & Co., vase, 1930; Transparent glass, with an internal series of overlapping bubbles; H. 15 in. (38 cm); Photo by Marino Barovier

Dis. Carlo Scarpa (Italian, 1906–1978) per Venini & Co., vase, 1942; Transparent glass, slightly iridescent with multicolored stripes; H. 16 ¹⁄₂ (cm 42); Photo by Marino Barovier

21: NASA/Solar Dynamics Observatory/ Atmospheric Imaging Assembly, Color Enhanced Telescope Image of Sun (*Popping all Over*), March 6-8, 2011

Solar and Heliospheric Observatory (European Space Agency and NASA), Color Enhanced Telescope Image of Sun (*Popping Off*), October 25–26, 2010

NASA/Solar Dynamics Observatory/ Atmospheric Imaging Assembly, Color Enhanced Telescope Image of Sun (*Great Ball of Fire*), August 1, 2010

25: Photo by Chuck Lysen

29: Photo by Chuck Lysen

31: Photo by Chuck Lysen

36–37: Photos by Chuck Lysen

39: Photos by Chuck Lysen

76: Photo by Chuck Lysen

77: Photo by Chuck Lysen

103: Venini & Co., Wall sconce for the Gorizia post office; Courtesy of Anna Venini archives

Luigi Piccinato (Italian, 1899-1983), Series of wall sconces designed in 1930; Courtesy of Anna Venini archives

104: Paolo Venini (Italian, 1895–1959), Glass Ceiling, Palazzo Grassi, 1952; Courtesy of Anna Venini archives

Paolo Venini (Italian, 1895–1959), Glass Ceiling, Palazzo Grassi (detail), 1952; Courtesy of Anna Venini archives

Paolo Venini (Italian, 1895–1959), 1958 World's Fair, Brussels, Italian Pavilion with polyhedron chandeliers; Courtesy of Anna Venini archives

105: Venini & Co., Murano, 1951. From left, front: Anna Venini, Frank Lloyd Wright, Bruno Zevi, Iovanna Lazovich, and Oscar Stonorav; back: Sabinae Masieri, the painter Mario de Luigi (wearing glasses), Giuseppe Samonà, Carlo Scarpa, and Angelo Masieri. Upon Masieri's premature death, Wright was asked to design a building on the Grand Canal in his memory, but the project was never built; Courtesy of Anna Venini archives

Oscar Stonorov (designer); window for the United Automobile Workers main conference hall (Detroit), 1957; Glass panels *a pennellate* mounted into lacquered aluminum frames; 10 feet (300 cm) x 15 feet (450 cm); Courtesy of Catalogo Nero, Job Reference Ditta Venini

106: Venini & Co., Schweinfurt Theater drop system, Germany, 1967; Courtesy of Da Rin Perego Architetti Associati archives

Dis. Carlo Scarpa (Italian, 1906–1978) (designer), The Caminentto (Fireplace) using polyhedrons for the Expo in Turin, 1961; Courtesy Anna Venini archives

Venini & Co., Schweinfurt Theater drop system (detail), Germany, 1967; Courtesy of Da Rin Perego Architetti Associati archives

Ludovico Diaz de Santillana (Italian, 1931–1989) (designer) per Venini & Co., lighting elements for lobby interior, World Trade Center, New York; Photo by Claudio Paggiarin, Courtesy of Da Rin Perego Architetti Associati archives

Venini & Co., Banco del Santo Spirito, Rome; Courtesy of Da Rin Perego Architetti Associati archives

Ludovico Diaz de Santillana (Italian, 1931–1989) (designer) per Venini & Co., lighting pylon with reedlike lighting for World Trade Center, New York; element is visible to the right of the sphere by Fritz Koenig; Photo by Claudio Paggiarin, Courtesy of Da Rin Perego Architetti Associati archives

107: Dale Chihuly (American, born 1941), Venini Model, 1968; Glass, plastic, neon; 36 x 18 in. (91.5 x 45.75 cm); The only work created by Chihuly at Venini & Co.; Courtesy of Anna Venini archives

108: Laura de Santillana (Italian, born 1955), Varaha, 2007; Blown glass

bronze mesh; 12 x 7 ¹/₂ in. (30.5 x 19 cm); Photo by Fabio Zonta

109: Alessandro Diaz de Santillana (Italian, born 1959), Untitled (Mudac), 2011; Blown and cut mirrored glass on plywood, silver foil on gesso; 81 x 49 ¹/₂ x 2 ¹/₂ in. (206 x 126 x 9 cm); Photo by Alessandro Diaz de Santillana

Alessandro Diaz de Santillana (Italian, born 1959), M1, 2005; Mirrored blown and flat glass, silver oxides, gold leaf on gesso, on plywood, 92 x 47 ¹/₄ x 6 in. (235 x 120 x 15 cm); Photo by Fabio Zonta

110: Alessandro Diaz de Santillana (Italian, born 1959), Trittico Arancio, 2000; Blown and slumped glass, mirrored, on plywood, lead, 80 x 36 x 5 ¹/₄ in. (203 x 91.5 x 13 cm); Photo by Alessandro Diaz de Santillana

112: Laura de Santillana (Italian, born 1955), Bodhi orange/gold, 2008; Blown and silvered glass; 18 x 17 in. (45.75 x 43 cm); Photo by Fabio Zonta

Laura de Santillana (Italian, born 1955), A-au, 2002, Blown glass with gold foil; 18 x 17 x 2 in. (45.75 x 43 x 5 cm); Photo by Fabio Zonta

113: Laura de Santillana (Italian, born 1955), "glass books" case, n.d.; Photo by Fabio Zonta

115: Alessandro Diaz de Santillana (Italian, born 1959), Untitled (ER2), 2007; Blown and cut mirrored glass on plywood, white gold leaf on gesso; 177 x 67 x 4 in. (450 x 170 x 12 cm); Photo by Alessandro Diaz de Santillana

116: E. Soulier and J Andriveau-Goujon, Atlas Elementaire Simplifie De Geographie Ancienne Et Moderne, 1838, 15 ¾ x 19 ¾ in. (40 x 50 cm); David Rumsey Historical Map Collection

Votive stupa, Bodhgaya, 11th–12th century (1001–1200); Sandstone, 40 ¹/₈ x 13 x 12 ¹/₄ in. (102 x 33 x 31 cm); Collection of The Ashmolean Museum of Archeology and Art, Oxford University; EAOS.59

NASA Earth Observatory, Satellite Photograph of Extratropical Cyclones Near Iceland, November 20, 2006

Lingam at Thousand-Pillared Temple, Warangal, Andhra Pradesh, India, 2003; Photo by David Boyk

117: Chandra X-ray Observatory and Hubble Space Telescope composite image of Cat's Eye Nebula Redux; X-ray courtesy of NASA/Chandra X-ray Observatory/Smithsonian Astrophysical Observatory, optical courtesy of NASA/Space Telescope Science Institute

Pollock, Jackson (1912–1956) © ARS, NY. One (Number 31, 1950), 1950. Oil and enamel on unprimed canvas, 8' 10" x 17' 5 ⁵/₈". Sidney and Harriet Janis Collection Fund (by exchange). The Museum of Modern Art, New York, NY, U.S.A.; Digital Image © The Museum of Modern Art/Licensed by SCALA/Art Resource, NY.

European Space Agency/German Aerospace Center/Freie University Berlin, Color Enhanced Telescope image of Residual Water Ice Vastitas

Borealis Crater, February 2, 2005; Photo by G. Neukum

118: Artist's sketchbook; Photo courtesy of the artists

An old Indian painting of Lord Vishnu resting on Ananta-Sesha, with Lakshmi massaging His feet, 18th century; Photo courtesy of http://en.wikipedia.org/wiki/File:Anantavishnu.jpg, public domain image

Laura de Santillana (Italian, born 1955), Sky, 1997; Photo by Fabio Zonta

Stone model of the Mahabodhi temple, Bodhgaya, mid-11th century; Stone, 4 ³/₈ x 3 /12 x 2 in. (11.1 x 8.8 x 5 cm); Collection of The Ashmolean Museum of Archeology and Art, Oxford University; EA1996.4

119: Paper factory, Ahmedabad, India; Photo by Laura de Santillana

Jain temple, Jaipur, India; Photo by Laura de Santillana

Nandi and its wandering companions, India; Photo by Laura de Santillana

The Jantar Mantar, 18th century, Jaipur, India; Photo by Laura de Santillana

Laura de Santillana (Italian, born 1955), Untitled (Moon), 1996; Photo by Fabio Zonta

Working sketch of a mountain; Photo by Russell Johnson

120–121: Photos by Russell Johnson